IMAGES
of America

SLOSS FURNACES

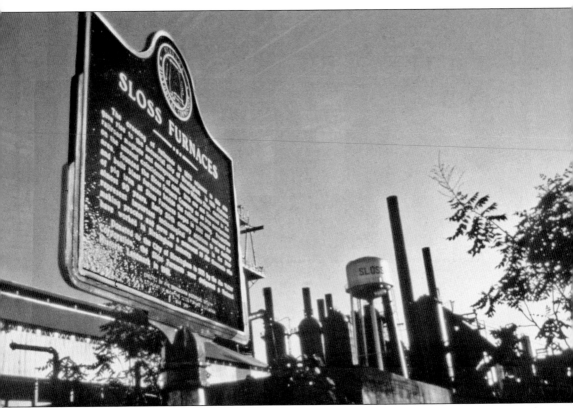

Sloss Furnaces was granted National Historic Landmark recognition in 1981 and opened to the public on Labor Day 1983. It is the only 20th-century blast furnace in the nation being preserved and interpreted as an industrial museum. Sloss Furnaces has become an international model for similar preservation efforts and presents a remarkable perspective on the era when America grew to world industrial dominance.

ON THE COVER: A worker "taps" the No. 2 Blast Furnace at Sloss. The furnaces were tapped every four hours, and each furnace produced over 400 tons of pig iron a day. The majority of Sloss pig iron was sold to producers of cast-iron pipe. Pig iron is the metallic iron that has been extracted from raw iron ore and cast into bars called pigs. (Courtesy of Sloss Furnaces National Historic Landmark.)

IMAGES
of America

SLOSS FURNACES

Karen R. Utz on behalf of
the Sloss Furnaces Foundation

ARCADIA
PUBLISHING

Copyright © 2009 Karen R. Utz on behalf of the Sloss Furnaces Foundation
ISBN 978-0-7385-6623-8

Published by Arcadia Publishing
Charleston SC, Chicago IL, Portsmouth NH, San Francisco CA

Printed in the United States of America

Library of Congress Control Number: 2009925979

For all general information contact Arcadia Publishing at:
Telephone 843-853-2070
Fax 843-853-0044
E-mail sales@arcadiapublishing.com
For customer service and orders:
Toll-Free 1-888-313-2665

Visit us on the Internet at www.arcadiapublishing.com

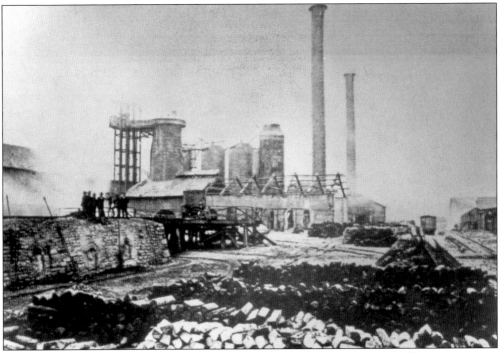

During the 1880s, as pig iron production in Alabama grew from 68,995 to 706,629 gross tons, no fewer than 19 blast furnaces would be built in Jefferson County alone. The second of these would be built by James Withers Sloss. Construction of the No. 1 Furnace began in June 1881, when ground was broken on a 50-acre site that had been donated by the Elyton Land Company—the land company responsible for developing the rich mineral district of Jones Valley and the city of Birmingham.

CONTENTS

ACKNOWLEDGMENTS

Since Sloss Furnaces was granted National Historic Landmark recognition in 1981, numerous people have contributed their time and talents to preserve this remarkable Southern industrial site. It is impossible to thank everyone individually, but without their hard work and appreciation of local history, this book would not have been possible. The Sloss staff—executive director Dr. Robert Rathburn, Ph.D., Paige Wainwright, Kimbelle Fipps, Rachael Weekley, Joy Hullett, Matt Landers, Carnell Holifield, Kye Wingo, and Ron Bates—offered invaluable advice and support. I am grateful to Marjorie White of the Birmingham Historical Society and Jim Baggett of the Birmingham Archives for their continual support and expertise. I owe thanks to the late Alvin Hudson for sharing his vast photography collection with Sloss Furnaces National Historic Landmark (SFNHL). I am indebted to Remy Hanemann, Sloss metal artist, who provided his knowledge and expertise on the Sloss Metal Arts Program. Thanks to John Springer, assistant curator (2002–2008), for his "technical" assistance and continual support of SFNHL. And special thanks to Jim Waters, founding member and past president of the Sloss Furnace Association, who outlined the first restoration site plan in the early 1980s. Lastly, I am especially grateful to the late Dr. W. David Lewis of Auburn University for his thorough research of Birmingham's rich industrial history.

Unless otherwise noted, all images appearing in this book were graciously provided by Sloss Furnaces National Historic Landmark.

INTRODUCTION

In 1871, seeking to diversify northern Alabama's economy, several prominent Alabamians founded the city of Birmingham with the explicit goal of exploiting the mineral resources of north-central Alabama (Jones Valley), where every ingredient necessary for making iron (limestone, coal, and iron ore) could be found within a 30-mile radius. One of these men was James Withers Sloss, a north Alabama merchant and railroad man.

Sloss was born of Scotch-Irish descent in Mooresville, Alabama, in 1820. His father, Joseph, emigrated from County Deery, Ireland, to Lexington, Virginia, with his parents in 1803. Joseph later moved to Tennessee, where he met and married Clarissa Wasson from Alabama. They later moved to Mooresville to farm and raise a family. At 15, his oldest son, James, became an apprentice bookkeeper for a local butcher. At the end of his seven-year term, he married a local girl, Mary Bigger, and used his savings to buy a small store in Athens, Alabama. By the 1850s, James Withers Sloss had extended his mercantile interests throughout northern Alabama and eventually evolved into one of the wealthiest merchant and plantation owners in the state.

In the early 1860s, realizing the need for the expansion of Southern rail lines, Sloss became active in railroad construction. As Birmingham journalist Ethel Armes later noted in a 1910 newspaper article, "Sloss had a voice in county and state politics, and was taking up the fight for railroads with vigor, and that good Irish tongue of his to boot." In 1867, following years of negotiations, all rail lines between Nashville and the Tennessee River were consolidated into one company, the Nashville and Decatur, with James W. Sloss as its first president.

During this post–Civil War period, Sloss not only promoted the expansion of Southern rail lines, but he became one of the chief proponents of Alabama's postwar industrial development, most notably the area around present-day Birmingham. As one local newspaper stated years later, "His influence will be found connected with every important industrial and commercial enterprise in the State during the latter half of the nineteenth century." Besides his connection with early industry, Sloss also became allied with the strongest railroad in the South—the Louisville and Nashville, better known as the L&N. He realized that the L&N had reached a critical stage in the South and greatly needed to find an outlet through Alabama to the Gulf of Mexico, where they wanted access to new markets and connections with Montgomery and Mobile. Aware of this interest, Sloss seized the opportunity to forge an alliance between the L&N and the Elyton Land Company (the company eventually responsible for developing the mineral district of Jones Valley and the city of Birmingham).

The decision to bring in the L&N transformed Birmingham from a squalid jumble of tents, shanties, and boxcars into a thriving community. While speaking at the Elyton Land Company's annual meeting in 1873, James Powell, an early Birmingham promoter, coined the community's nickname, "the Magic City," by referring to "this magic little city of ours."

In 1878, determined to tap the rich mineral areas surrounding Birmingham, Henry DeBardeleben, son-in-law and heir to the Pratt cotton gin fortune, joined forces with Sloss and Truman Aldrich,

a successful mining engineer, to form the Pratt Coal and Coke Company, the first large coal company in Alabama. Pratt soon became the largest mining enterprise in the district. In 1882, the Pratt Company sold out to Memphis entrepreneur Enoch Ensley, who invested close to $1.5 million and increased mining operations to a daily output of 2,500 tons. By 1885, Ensley's Pratt Company owned 70,000 acres of coal lands, 710 coke ovens, and 30 miles of railway. With over 1,000 free and convict laborers, the Pratt mines produced "first class coking coal" for pig iron furnaces throughout the Birmingham area. Tennessee Coal and Iron (TCI) acquired the company in 1886 and immediately added additional mines to the Pratt holdings.

In 1879, inspired by the success of the Pratt Company, DeBardeleben created Alice Furnace, named for his oldest daughter. Known as "Little Alice," it set off a wave of furnace construction that was later referred to as "The Great Birmingham Iron Boom."

During the 1880s, as pig iron production in Alabama grew from 68,995 to 706,629 gross tons, no fewer than 19 blast furnaces would be built in Jefferson County alone. The second of these stacks would be built by James Sloss. In 1880, with the economic backing of Henry DeBardeleben, Sloss founded the Sloss Furnaces Company. After its first year of operation, the furnace had sold 24,000 tons of iron. At the 1883 Louisville Exposition, the company won a bronze medal for "best pig iron."

James W. Sloss not only exported his iron but managed to supply large amounts for local agricultural purposes, items such as traps, pipes, and stoves. The majority of Sloss pig iron, however, ended up in Cincinnati, Louisville, St. Louis, Nashville, Chicago, Detroit, and Cleveland. Pig iron costs in Northern plants averaged $18.30 per ton in 1884 while pig iron in the South could be produced for $10–$11 a ton.

As Birmingham flourished, so did Sloss. Colonel Sloss retired in 1886 and sold the company to a group of financiers, who guided it through a period of rapid expansion. The company reorganized in 1899 as Sloss-Sheffield Steel and Iron, although it was never to make steel. With the acquisition of furnaces and extensive mineral lands in northern Alabama, Sloss-Sheffield became the second largest merchant pig iron company in the Birmingham District. Company assets included 7 blast furnaces, 1,500 beehive coke ovens, 120,000 acres of coal and ore land, 5 Jefferson County coal mines, and 2 red ore mines, quarries in North Birmingham, brown ore mines in Russellville, and 1,200 tenements for its workers.

By far, the most important foundry product that stimulated the growth of Sloss-Sheffield and the emergence of the Southern foundry trade was cast-iron pipe, used for transporting water, sewage, chemicals, fuels, gases, and other substances. Two general classes of pipe were produced: soil pipes (through which water or other substances flowed under the force of gravity) and pressure pipes (through which substances were pumped under force).

In 1914, at the start of World War I, Sloss-Sheffield was among the largest producers of pig iron in the world. By 1917, when America entered the war, military service claimed approximately 700 of Sloss-Sheffield employees. In the same year, Sloss-Sheffield's total assets of $27 million ranked 28th among primary metal manufacturers in the United States and 206th among all industrial firms.

Following World War I, the Great Depression that began in the 1920s proved extremely stressful for the company. In October 1925, the directors of Sloss-Sheffield, realizing they would never survive the Depression if they did not modernize, authorized $625,000 toward a massive rebuilding program. Starting early the following year, the No. 2 Furnace was completely dismantled and reconstructed; the following year, the No. 1 Furnace was rebuilt. Each of the new furnaces had an average daily capacity of 400 to 450 tons compared to a previous maximum output of about 250 tons. These innovative changes helped to carry Sloss-Sheffield through America's worst economic crisis.

In 1933, the nation was in dire straits when Franklin D. Roosevelt assumed the presidency. In 1938, at the height of the Great Depression, Roosevelt described the American South as "the nation's number one economic problem." But in 1939, World War II resurrected the South's economy and encouraged its leaders to take whatever action was necessary to keep their states from slipping back into the desperate poverty of the 1930s.

As Sloss-Sheffield switched from peacetime to wartime operations, large amounts of its cast iron were used in fragmentation and incendiary bombs, as well as mortar shells, marine engines, and hand grenades. About 60 percent of all hand grenades used by American forces in the war came from the Birmingham area.

By 1941, when America entered the war, Birmingham's population surpassed 226,000 and Jefferson County's over 431,000. Nearly half the labor force was employed by the iron and steel and mining districts; more than two-thirds of the industries' workers were African American.

Despite being dominated by black labor, the industrial workplace was rigidly segregated until the 1960s. At Sloss, for example, men bathed in separate bathhouses, punched separate time clocks, and attended separate company picnics. More important was the segregation of jobs. The company operated as a hierarchy. At the top, there was an all-white group of managers, accountants, engineers, and chemists; at the bottom, an all-black labor gang. In the middle, a racially mixed group performed a variety of skilled and semi-skilled jobs. Even in the middle group, however, white workers held the higher-paying, higher-status "title" positions: stove-tenders, boilermakers, carpenters, and machinists. Black workers were restricted to such "helper" roles as carpenter helper, machinist helper, and stove-tender helper.

Segregation at the workplace simply mirrored living conditions away from the plant. As Birmingham's population exploded in the late 19th century, Sloss Furnaces, Tennessee Coal and Iron Company, and numerous other furnaces and mines built low-cost housing throughout the Birmingham area.

Sloss Quarters, the 48 houses adjacent to the actual Sloss site, were designed especially for African American workers pouring in from the Black Belt areas of Alabama and Mississippi. They were typical shotgun-style structures, with two rooms set on foundation posts and, in the early years, no indoor plumbing. Until the 1930s, drinking and cooking water came from a faucet placed at the end of each row of houses. Rain barrels caught water for the laundry. Nonetheless, many of these homes were an improvement over the sharecropper shacks supplied by landowners.

Housing in the Quarters served two purposes; it attracted family men, thus lowering the rate of absenteeism, and made available a ready supply of black labor in case of emergencies. And despite the drawbacks, the Quarters provided a relatively cohesive community setting for workers and their families coming in from various areas of the rural South, a community where people had the same customs, shared the same beliefs, and shared the same problems. Social events that tied neighbors together on the farms became the typical neighborhood gatherings in urban settings. Watermelon cuttings, barbeques, chittlin' suppers, quilting bees, baseball games, and church suppers were but a few of the social events organized by the women of the Quarters.

Sloss Quarters was dismantled in the late 1950s as maintenance and repairs became a drain on the company's resources. At the same time, higher wages, improved transportation, and environmental concerns encouraged residents of the Quarters to seek better housing away from the plant.

Major changes were also happening at the Sloss industrial site. On September 12, 1952, Sloss-Sheffield merged with U.S. Pipe and Foundry and Claude Lawson, president of Sloss-Sheffield, became the new president of U.S. Pipe. While the new headquarters was being built, a major modernization program, the first that Sloss-Sheffield had undertaken since 1931, got underway in North Birmingham. The blast furnace at this site was the largest and most modern installation ever built in the United States for making foundry pig iron.

Even as it was being built, the American iron and steel industry was beginning to face severe foreign competition. Some of it came from West German plants that had been destroyed by Allied bombing attacks during World War II and rebuilt under the Marshall Plan. Foreign plants began exporting low-cost iron and steel to American markets that were no longer protected by high tariffs. In the 1960s, technological changes (introduction of ductile iron and plastic pipes), an increased reliance on scrap iron, and stricter air pollution standards changed Birmingham's industrial economy. In 1970, Sloss Furnaces, the oldest remaining blast furnace in Birmingham, was "banked" and donated to the Alabama State Fair Authority. In 1972, the site was placed

on the National Register of Historic Places, but little funding was available for its development. Finally in 1976, the Historic American Engineering Record (HARE) conducted a detailed survey of the Sloss Furnace property, jointly funded by the Birmingham City Council and the National Parks Service, to assess its historical significance and prepare a permanent architectural record. In the spring of 1977, the City of Birmingham earmarked $3 million for refurbishing the furnaces and turning them into an industrial museum.

In a series of meetings at city hall in the fall of 1977, Jim Waters, an architect who became president of the Sloss Furnace Association (comprised of individuals from all backgrounds interested in preserving the site), outlined a plan to restore the site. In May 1981, following an extensive 16-month restoration plan, Sloss Furnaces became one of only 87 sites in the United States to be designated as a National Historic Landmark.

Sloss is currently the only 20th-century blast furnace plant in the nation being preserved and interpreted as an industrial museum. For Birmingham, however, Sloss is important and significant because of what it represents. There is not a single major historical issue in the city's first 100 years that is not related directly to Sloss—the importance of railroads, an economy built on heavy industry, company towns, and segregation. The very character of the city is traceable to heavy industries like Sloss.

Today Sloss is not only dedicated to preservation and education, but numerous parts of the site have been adapted for use as a center for community and civic events such as rock concerts, symphony events, weddings, reunions, and barbeque festivals.

Sloss also houses an innovative and active metal arts program—one of the best in the nation. The program offers public workshops and classes that address all aspects of creating metal sculpture—pattern making, mold making, casting, welding, cutting, and forging. This unique program is rooted in Birmingham's historic connection to iron and steel and replicates the industrial processes that took place in Birmingham for more than 100 years.

Sloss Furnaces is more than a landmark or museum—it represents the character and spirit of the South's industrial heritage. As one former worker stated, "A lot more than iron flowed from those furnaces. Our whole culture did. Our whole way of life."

One

JAMES W. SLOSS AND THE RISE OF BIRMINGHAM

Born of Scotch-Irish descent in Mooresville, Alabama, James W. Sloss (1820–1890) eventually evolved into one of the wealthiest merchant and plantation owners in the state. In 1878, determined to tap the rich mineral areas surrounding Birmingham, Sloss joined forces with local entrepreneurs Henry DeBardeleben and Truman Aldrich to form the Pratt Coal and Coke Company. In 1880, Sloss founded the Sloss Furnaces Company and, two years later, "blew-in" the second blast furnace in Birmingham.

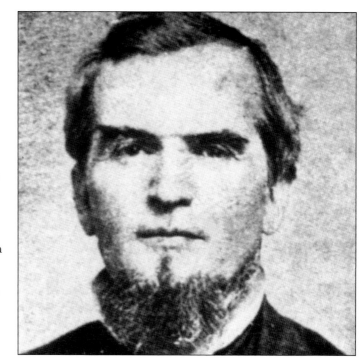

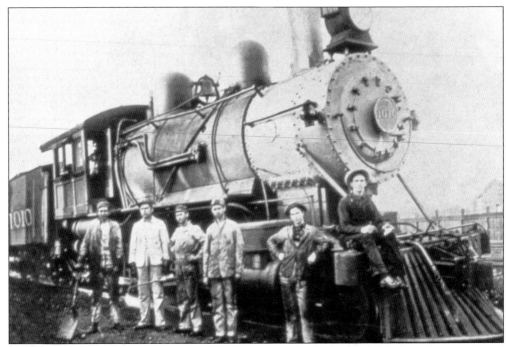

Sloss was determined to develop ties with an enterprise that had emerged as the strongest railroad in the South: the Louisville and Nashville. He realized that the L&N had reached a critical stage in the South and greatly needed to find an outlet through Alabama to the Gulf of Mexico, where they wanted access to new markets and connections with Montgomery and Mobile, Alabama. (Courtesy of the Birmingham Historical Society.)

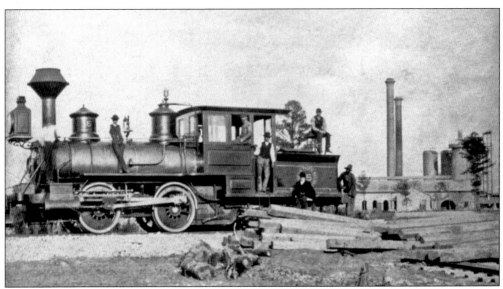

Ultimately reaching the Gulf of Mexico, the Louisville and Nashville Railroad invested more than $30 million in furnaces, mines, wharves, steamship lines, and other Alabama operations. By 1888, it was hauling annual tonnage of iron, coal, and other mineral products outweighing the nation's entire cotton crop. Steam locomotives were an essential part of early Birmingham industry.

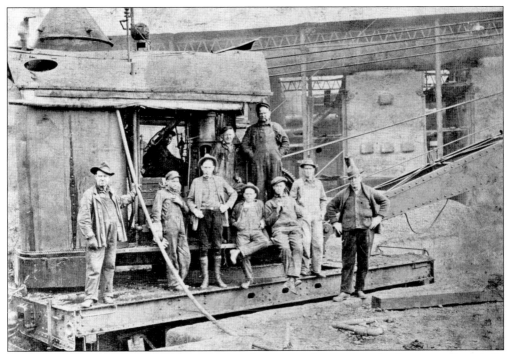

Birmingham's industrial boom attracted workers from across the nation and as far away as Europe. By 1896, the Birmingham industrial district had over 180 manufacturing plants, employing 3,400 furnace workers, 8,500 miners, and 9,500 men working at coke ovens, pipe works, and various other foundries located throughout Birmingham's industrial district. By 1910, the industrial labor force exceeded 30,000 men.

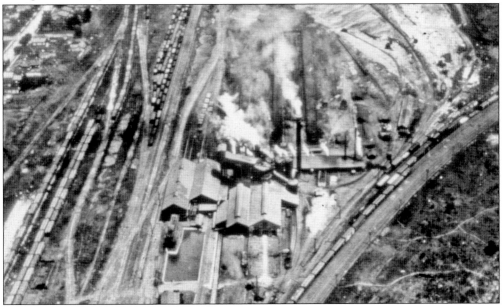

In 1879, Henry DeBardeleben, early Birmingham promoter and industrialist, joined forces with T. T. Hillman, grandson of Daniel Hillman, pioneer ironmaster and developer of Tannehill (a pre–Civil War cold blast furnace), to build the first blast furnace in the Birmingham District. Named for DeBardeleben's oldest daughter, the Alice Furnace went into blast on November 23, 1880.

13

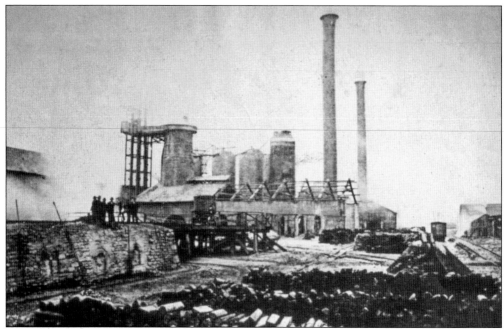

With capital advance by the L&N Railroad and the financial backing of good friend Henry DeBardeleben, James Sloss built his furnaces on 50 acres just east of Birmingham's central business district. Sloss's two sons served as officers of the company, Fred Sloss as secretary-treasurer and Maclin Sloss as general manager.

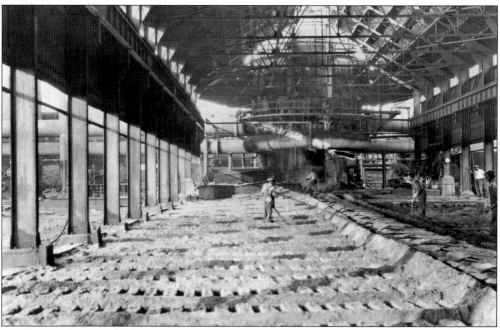

Prior to the mid-1920s, all molding was done by hand in the cast shed. Each shed had a gently sloping sand floor into which the mold was "imprinted" into the sand using tools. When the furnace was tapped, the molten iron poured out into a trough and ran downhill filling the molds. The pattern of the molds resembled piglets suckling at the sow, hence the name "pig iron."

Iron making was the quintessential Birmingham industry. The raw materials for making pig iron—iron ore, limestone, and coal—were available in abundance in the Birmingham area (as illustrated in this 1890s poster of early Birmingham). In the 1880s, as pig iron production in Alabama grew from 69,000 to 707,000 gross tons, 19 blast furnaces would be built in Jefferson County alone. (Courtesy of the Birmingham Historical Society.)

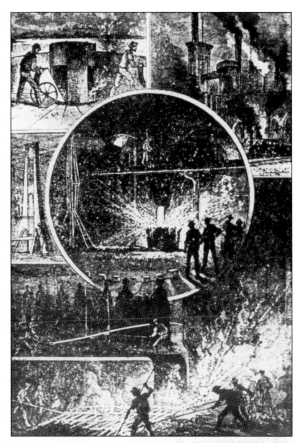

Because of its close proximity to raw materials and newly developed rail connections, Alabama industrialists were confident that iron could be made more cheaply in Birmingham's industrial district than in Northern industrial districts. James Powell, an early Birmingham promoter, coined the community's nickname by referring to "this magic little city of ours." (Courtesy of the Birmingham Historical Society.)

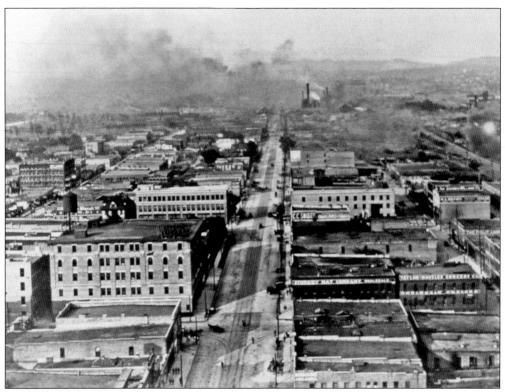

By the early 1900s, over 280 manufacturing firms—including mines, blast furnaces, machine shops, cast-iron pipe factories, and rolling mills—employed thousands of workers. As workers flocked to the smoky blast furnaces and mills, homes, churches, and businesses began to rise on vacant land throughout the city. (Courtesy of the Birmingham Public Library Archives.)

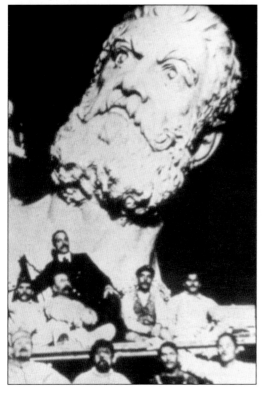

In 1903, the Commercial Club of Birmingham created a symbol for the growing industrial district—a statue of Vulcan, the Roman god of fire and metalworking. Designed by Italian sculptor Giuseppe Moretti and cast in Birmingham of Birmingham iron, the 55-foot statue was exhibited at the Louisiana Purchase Exhibition in St. Louis in 1904. (Courtesy of the Birmingham Public Library Archives.)

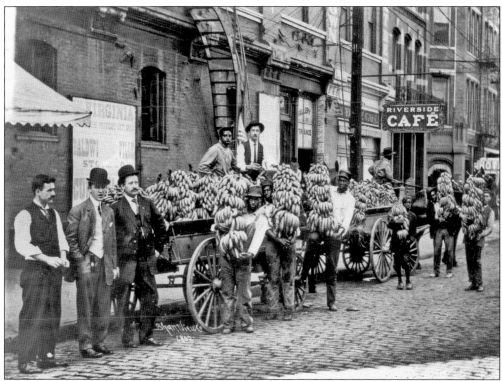

Alex Kontos (third from left), also known as the "Banana King," poses with his produce on Morris Avenue near the Morris Hotel. In 1903, Birmingham promoters advertised the area as the "Metropolis of the South" and the "fastest growing city in the United States." Immigrants from all over the world flocked to take advantage and contribute to its commercial and industrial growth. (Source unknown.)

The majority of immigrants coming to Birmingham's industrial district found employment in the coal and iron industry. By the dawn of the 20th century, Italians made up the largest immigrant group working in the surrounding mines and mills. A 1910 Birmingham census listed nearly 5,000 foreigners from 28 different countries.

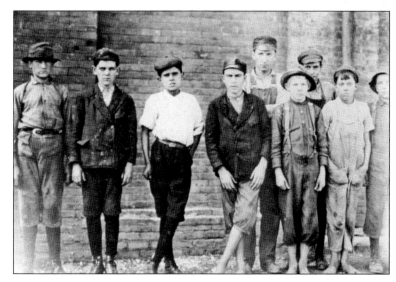

By the early 1900s, the industrial labor force exceeded 20,000 men. With their families, they made up around one-half of the total population of the city of Birmingham. The Pratt City district, along with the Ensley, Fairfield, and Wylam districts, had 18,000 industrial employees and a total population of over 140,000. (Courtesy of the Birmingham Historical Society.)

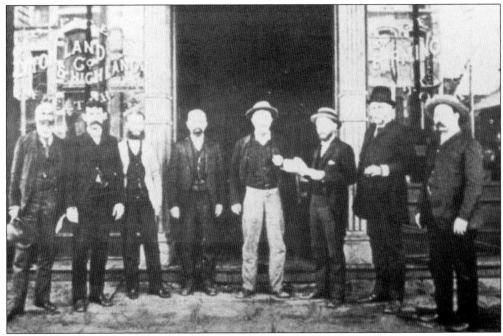

This is an early photograph of Birmingham land speculators, businessmen, and industrialists. The coal and iron boom of the late 1880s led to the influx of a number of land speculators and land companies—companies responsible for the creation of the manufacturing cities of Ensley, Wylam, and Bessemer. Many of these industrial cities would later become suburbs of the city of Birmingham.

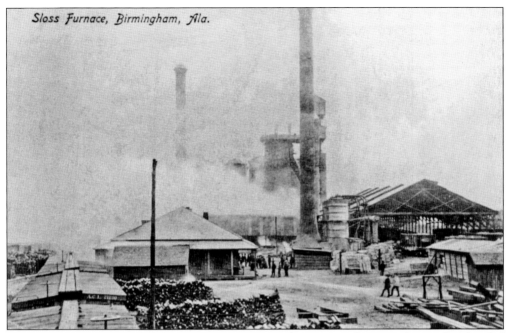

Sloss Furnace, Birmingham, Ala.

Sloss retired in 1886 and sold the company to a group of Virginia and New York capitalists headed by John W. Johnston, president of the Georgia Pacific Railroad, and Joseph F. Johnston, president of the Alabama National Bank. The company reorganized in 1899 as Sloss-Sheffield Steel and Iron, although it was never to make steel.

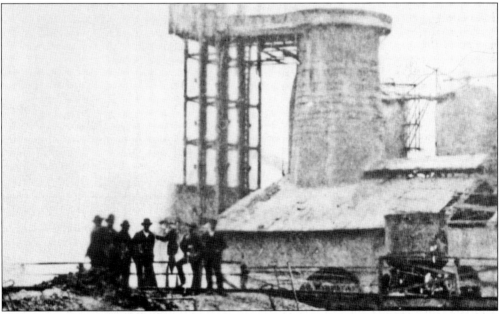

With the acquisition of furnaces and extensive mineral lands in northern Alabama, Sloss-Sheffield became the second-largest merchant pig iron company in the Birmingham District. Its assets included seven blast furnaces, 1,500 beehive coke ovens, 120,000 acres of coal and ore land, five Jefferson County coal mines and two red ore mines, quarries in North Birmingham, brown ore mines in Russellville, and 1,200 tenements for its workers.

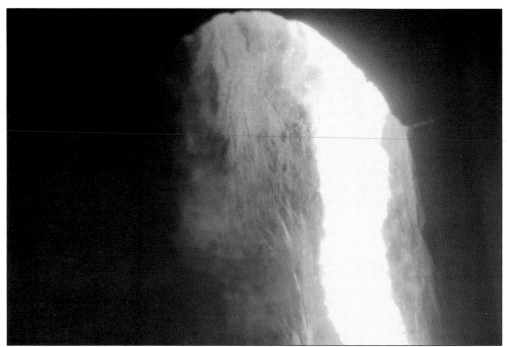

Industrial workers soon found out that laboring in a cast shed was not only extremely hot but called for a high degree of skill to ensure that each pig mold filled evenly. In the early 1900s, prior to mechanization, danger was ever present since a small amount of moisture in the molds could produce an explosion that would send molten metal flying in all directions.

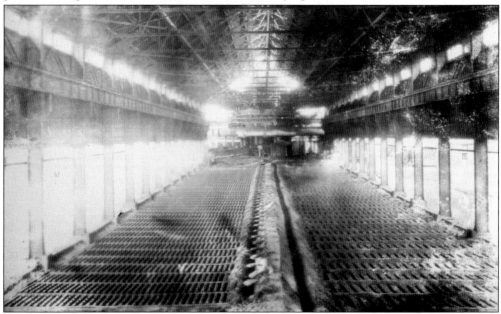

Working in the searing heat of casting sheds was grueling and perilous. After being broken apart, the pigs, weighing up to 125 pounds each, were cooled by being sprayed with water. Workers then loaded them onto mule-drawn tramcars that carried the metal to the furnace yard to await shipment. The 1,400 Sloss mules retired when the site installed electric cars in 1915.

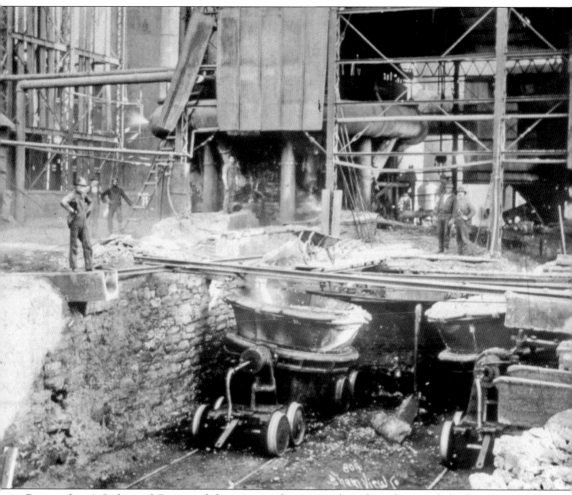

Birmingham's Industrial District did not enter the national steel market until the late 1890s. Despite many efforts to convert local ores to steel, the high phosphorous and silica content of the district's ore was a major obstacle. In 1889, the Henderson Steel Company plant manufactured the district's first steel.

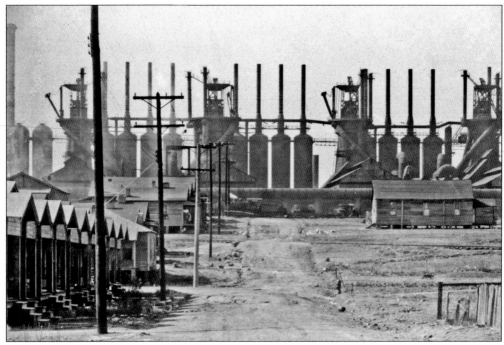

In 1888, Enoch Ensley, a wealthy planter and entrepreneur from Memphis, began the construction of four major blast furnaces with company housing located nearby. In 1892, the company's industrial facilities were consolidated with DeBardeleben's holdings to form the largest single industrial enterprise in the area, owned and operated by the Tennessee Coal, Iron, and Railroad Company.

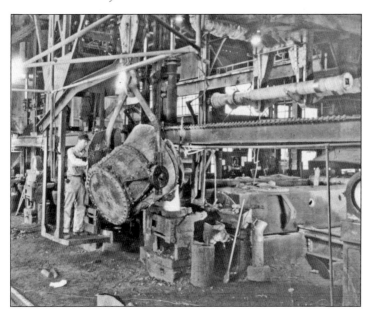

On October 5, 1905, the American Cast Iron Pipe Company purchased property north of Birmingham. Company founder Joseph Eagan initiated numerous services and benefits for his employees. Eagan offered his key employees 10 shares of company stock on their five-year anniversary. The North Birmingham plant is the largest individual pipe-manufacturing plant in the world.

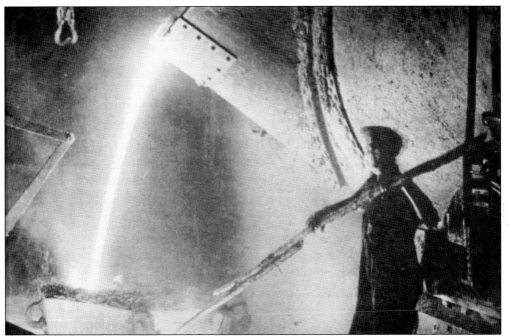

By the 1900s, Alabama was producing slightly more than 25 percent of the nation's foundry iron and had overtaken all the industrial areas of Pennsylvania. Of the 12 pipe foundries built throughout the nation between 1900 and 1914, seven were located in Alabama. By 1915, Alabama produced over a million tons of foundry iron against Pennsylvania's 871,718.

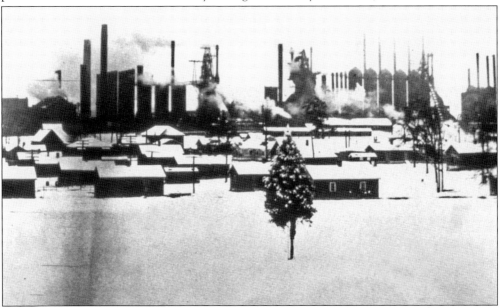

Joseph Woodward, founder of the Woodward Iron Company, completed the building of two blast furnaces in 1887 (with company housing in close proximity). The two Woodward furnaces had a combined capacity of 165 tons daily. In 1905, a third furnace was blown in. By 1909, the combined capacity of the three furnaces was 250,000 tons annually and over 2,000 men were on the Woodward payroll.

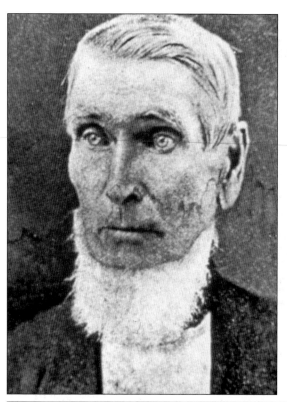

In 1884, Daniel Pratt, Alabama's first industrialist, sent an 11-ton "lump" of coal to the New Orleans World Exposition to ignite international interest in Birmingham's rich mineral resources. By 1885, the Pratt Company (later known as Pratt Consolidated Coal Company) owned 70,000 acres of coal land and 710 coke ovens and began producing the majority of first-class coking coal in the Birmingham area.

By 1910, dozens of coal mines were developed along Alabama's Warrior River. The Pratt Consolidated Coal Company was the largest commercial coal mining operation in the area and eventually opened a convict mine at its Banner mine location in 1902. In April 1911, an explosion at the mine killed 128 men, mostly black convicts.

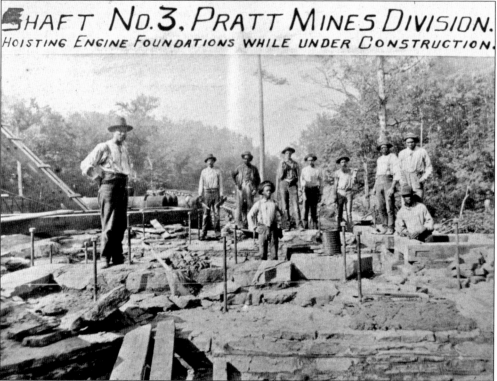

SHAFT No. 3. PRATT MINES DIVISION.
HOISTING ENGINE FOUNDATIONS WHILE UNDER CONSTRUCTION.

A magazine article written in the 1900s stated that the convict leasing system in the state of Alabama "was a relic of barbarism, a form of human slavery, and next to impossible for the average citizen unfamiliar with the conditions to grasp or comprehend." Alabama outlawed the convict leasing system in 1928.

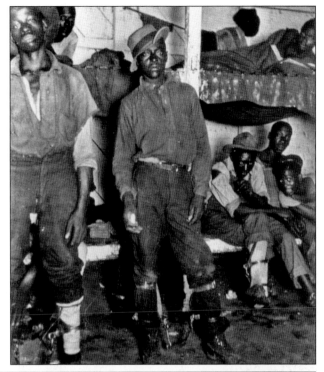

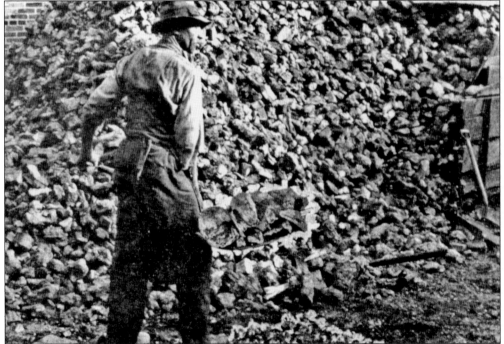

With 800 to 1,000 free laborers and convicts living at its mining camps, the Pratt Coke and Coal Company mines produced the majority of the coking coal for pig iron furnaces in the Birmingham district. By 1911, there were 40 companies operating 143 mines in Jefferson County and employing over 10,000 men.

By the late 1880s, the L&N Railroad had completed the Birmingham Mineral Railroad, as well as a 27-mile spur line to Blocton Junction. Here the DeBardeleben Coal and Iron Company opened mines to supply the newly constructed pig iron furnaces in Bessemer, Alabama. (Courtesy of the Birmingham Public Library Archives.)

In 1889, the L&N had completed the Blocton Branch line to Gurnee Junction where the Cahaba Coal Mining Company, under the direction of early Birmingham promoter Truman Aldrich, had opened several mining operations. At Blocton, Aldrich opened surface mines that became leading coal producers during the 1880s. (Courtesy of the Birmingham Public Library Archives.)

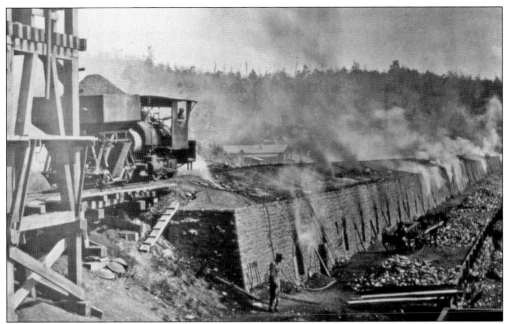

A substantial portion of coal was converted to coke in massive beehive ovens. In the late 1890s, there were over 5,000 beehive ovens in Alabama. A battery of Sloss beehives stool along the L&N and Southern tracks in downtown Birmingham. A local reporter stated, "Birmingham might be a heavenly place to live, but (because of the miles of beehive coke ovens) it looked like hell from a railroad train."

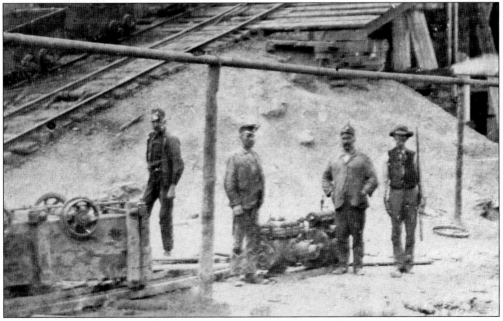

In 1892, an article in the *Handbook of Alabama* stated that Birmingham possessed an "inexhaustible supply of coal for furnace, steam and domestic uses." The article went on to explain, "The Alabama fields now stand at the head of the bituminous coal producing regions of the nation." In 1892, the Alabama coal industry employed over 6,000 workers and produced 4 million tons.

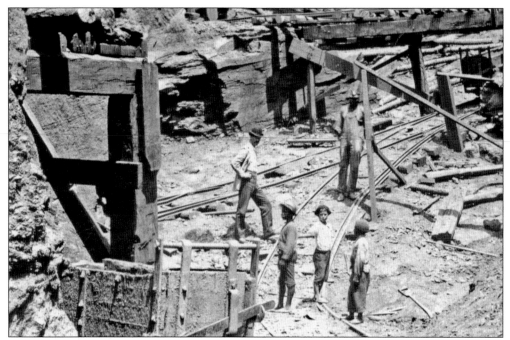

In 1887, Sloss-Sheffield purchased the Brookside, Cardiff, Brazil, and Blossburg Mines. The mines employed 400 to 500 men (including 200 convicts), who increased total production to 1,500 tons per day. The coking coal was used in the Sloss pig iron furnaces in North Birmingham and the downtown site. The mines were the district's second-largest producers.

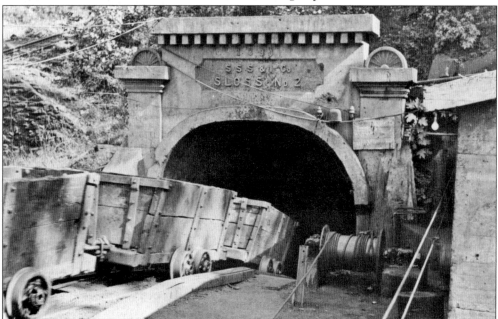

The third-largest coal producer in the Birmingham District was Sloss, with old mines at Coalburg and Blossburg and newly opened mines at Flat Top and Bessie. The Flat Top coal mine, run almost exclusively by convict labor, became Sloss's largest producer. In 1904, Sloss produced 1,400,669 tons of coal.

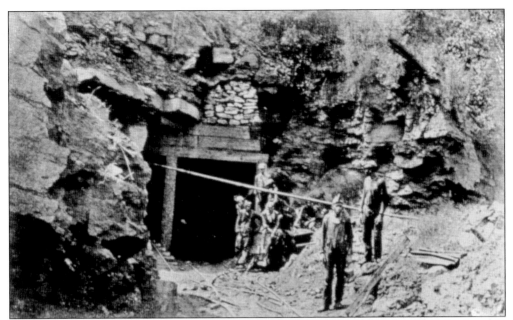

By the early 1900s, Birmingham's Coal and Iron Company was a major producer of red ore. In Birmingham's Red Mountain summit, red ore, or hematite, seams extended 16 miles from Ruffner Mountain, east of the city of Birmingham, to a point 4 miles south of the city of Bessemer. From 1864 until 1971, this ore supported the growth of Birmingham's iron and steel industry. (Courtesy of the Birmingham Historical Society.)

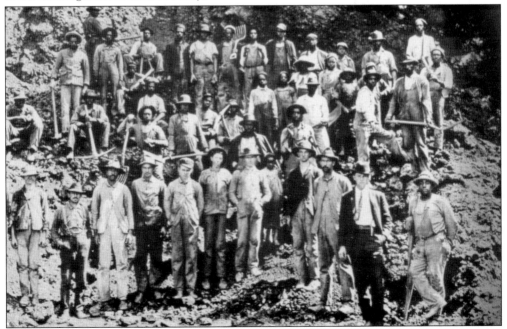

Besides needing to solve the difficulties inherent in smelting, the region's iron makers also had to cope with complications caused by excess silica, which created overheating in pig iron production. The silica content of Southern pig iron could be reduced by adding extra limestone to the furnace charge. By the 1900s, limestone quarries were found throughout Birmingham's Industrial District.

29

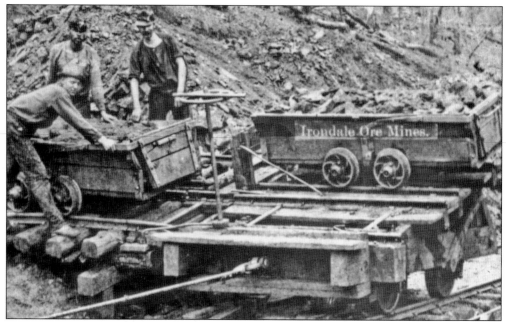

In 1887, with the Sloss Company opening red ore mines throughout the Red Mountain area, including Ruffner Mountain, 29 residents of Irondale, Alabama, petitioned for formal incorporation as a city. In 1905, the Seaboard Railroad extended tracks through Irondale into the city of Birmingham. By 1919, Irondale had a booming population of 525 residents. (Courtesy of the Birmingham Public Library Archives.)

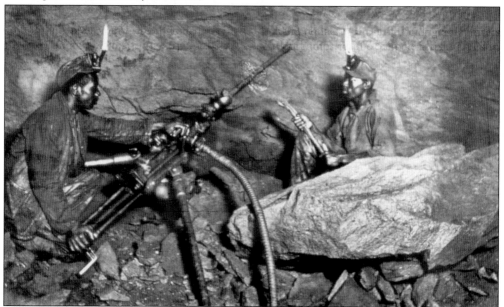

In 1881, before he started his furnace operations in downtown Birmingham, James Sloss bought extensive ore properties 7 miles south of Birmingham for $20,000. In the late 1880s and 1890s, Sloss opened three additional ore mines on Red Mountain at Irondale. The Sloss mines became the largest early producers in the district, extracting some 1,200 tons of ore daily by the mid-1890s. (Courtesy of the Birmingham Public Library Archives.)

Two

SLOSS "QUARTERS" AND BIRMINGHAM'S INDUSTRIAL HOUSING

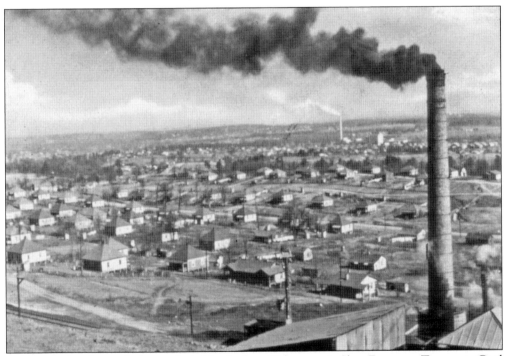

As Birmingham's population exploded in the late 19th century, Sloss Furnaces, Tennessee Coal and Iron, and numerous other industries built company towns and low-cost housing throughout Birmingham's Industrial District. Controlled company housing served two purposes: it attracted family men, thus lowering the rate of absenteeism, and made available a ready supply of workers in case of emergencies. (Courtesy of the Birmingham Public Library Archives.)

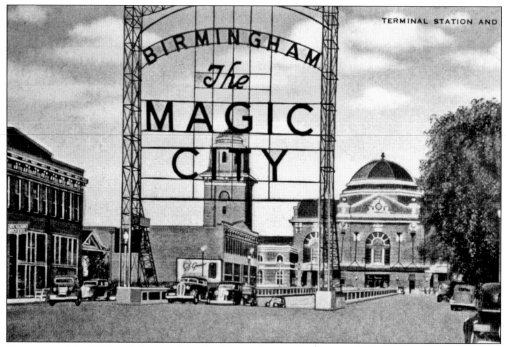

Constructed in 1907 and designed in the Beaux Arts style, Birmingham's Terminal Station was considered the most elaborate railroad facility in the South. By 1910, as people flocked to the mines, furnaces, and mills of Birmingham's Industrial District, the volume of rail traffic at the Birmingham terminal surpassed that of all other Southern cities.

From 1910 to 1920, Birmingham's growth was spurred by a booming industrial market and World War I. Although the growth of the city was attributed to iron and steel manufacturing, sawmills and cotton gins contributed to Birmingham's industrial boom. Avondale Mills, established in the city in the late 1890s, was a major Alabama textile producer.

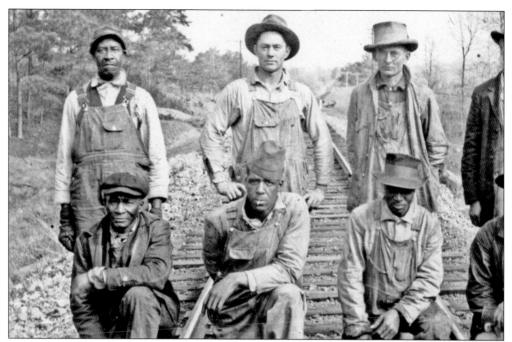

Birmingham's booming industrial district attracted migrants from as far away as Italy, Germany, Ireland, and Greece. The majority, however, were African American migrants from rural Alabama, Louisiana, and Mississippi. They hoped to escape the desperate rural poverty brought on by the sharecropping system and find jobs and a better life for their families.

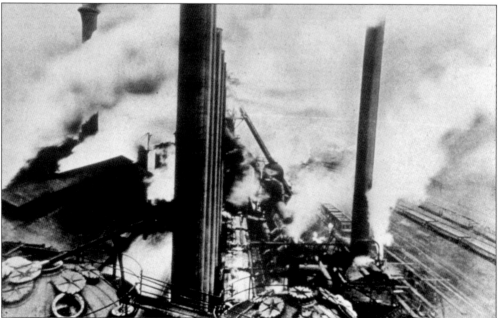

By the early 1900s, with cotton prices continually dropping, many farmers had decided that their only path to financial freedom was to leave their farms and head for the "smokestacks" of Birmingham. A newly arrived worker recalled, "The reason we came to Birmingham was 'cause cotton was down to nothin.' If you farming, you couldn't pay the landlords, you couldn't pay your bills."

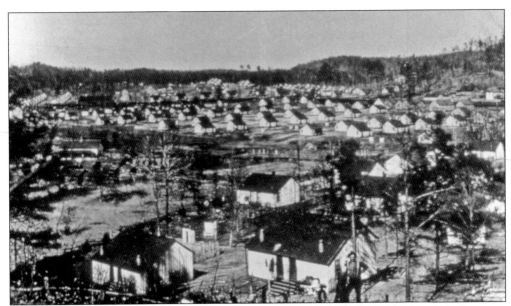

By the 1880s, mining camps were located throughout the Red Mountain district from Bessemer to Ruffner Mountain. For mining industrialists, the construction of company camps near their isolated mines was an absolute necessity. The bleakness of camp life in the early 1900s brought large numbers of miners into Birmingham, where their wages could buy alcohol and entertainment.

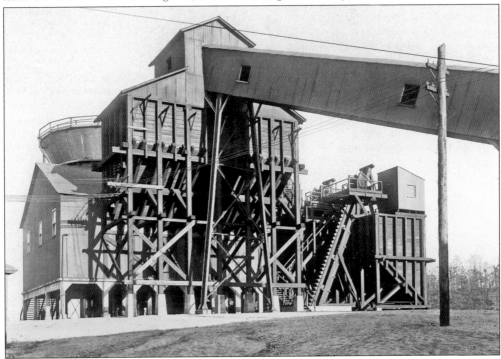

With the expansion of railroad service in the early 1900s, Birmingham experienced yet another coal boom. In 1904, the Pratt Consolidated Coal Company was one of Alabama's largest coal companies and operated 18 mines. On these mining sites were 800 tenement houses, 14 churches, and eight stores. (Courtesy of the Birmingham Public Library Archives.)

The company store (or commissary) served as a post office, pay office, shopping center, and overall "gathering" place. Despite the obvious drawbacks, some company towns provided a relatively cohesive community setting for workers and their families—a community where people had the same customs, shared the same beliefs, and shared the same problems.

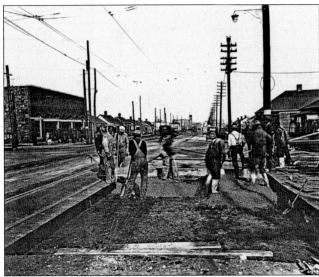

This 1900s photograph shows workers repairing a road in front of the Sloss Commissary and company housing. By the late 1890s, the Sloss Company maintained housing for its employees at its furnaces in downtown Birmingham and North Birmingham. The 48 houses adjacent to the downtown site were built for African American workers and were known as the "Quarters."

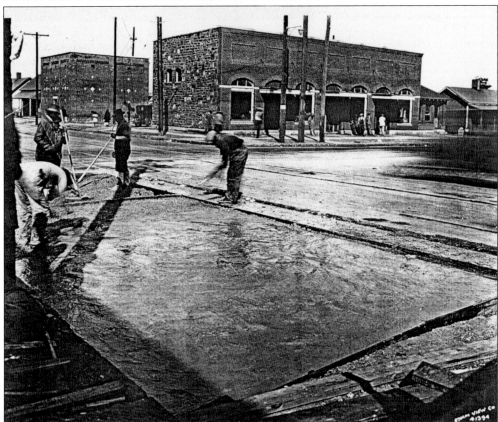

The Sloss commissary was the heart and soul of the community and served as shopping center and pay office. Until the 1920s, workers paid for items with company scrip called "clacker." The Quarters was dismantled in the late 1950s as maintenance and repairs became a drain on the company's resources. At the same time, higher wages, improved transportation, and environmental concerns encouraged workers to seek better housing away from the site.

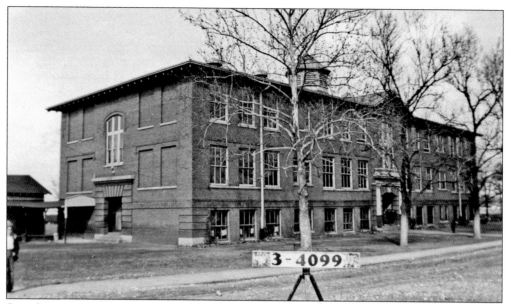

Social events that tied neighbors together on the farms became the typical neighborhood gatherings in the Quarters. Watermelon cuttings, barbeques, chittlin' suppers, and quilting bees were but a few of the social events organized by the women of Sloss Quarters. And with Thomas School nearby, black children had access to educational opportunities almost unheard of in the rest of the South.

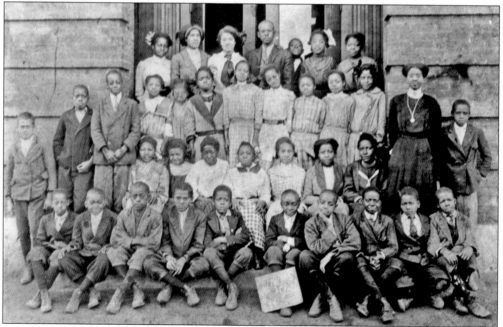

In addition to neighborhood parties, the residents of the Quarters instituted a kind of "neighborhood watch" program to keep an eye on the children when school was out. A former resident of the Quarters recalled, "Everyone knew everybody. Children couldn't get into no devilment away from home because another adult might whip them and they'd get two whippings." (Courtesy of the Birmingham Public Library Archives.)

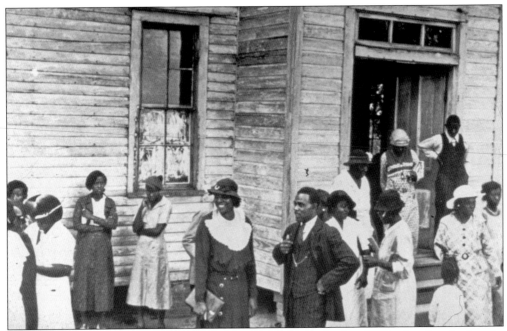

From the beginning of black migration into Birmingham in the late 1800s, the church played a crucial role in the African American community, especially in the lives of the women. And just as they had when living in the country, the women of the Quarters used the majority of their free time in church-related activities. (Courtesy of the Birmingham Historical Society.)

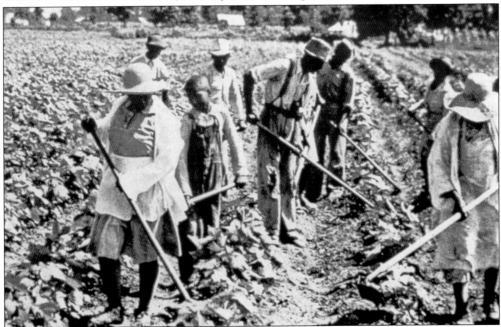

Sloss Quarters did not become a successful and cohesive community because of the men who labored in the neighboring blast furnaces; it thrived and succeeded because of the women who were determined to make a better life for themselves and their families away from the desperate poverty of their previous rural existence.

Companies like Sloss Furnaces and Stockham Pipe and Fitting Company (a successful Birmingham valve and pipe company) encouraged team sports. Sloss administrators believed that organized company team events, although segregated, were not only recreational outlets, but taught employees the importance of cooperation and encouraged pride and dedication in the company. Many of Birmingham's African American players went on to play for the Birmingham Black Barons.

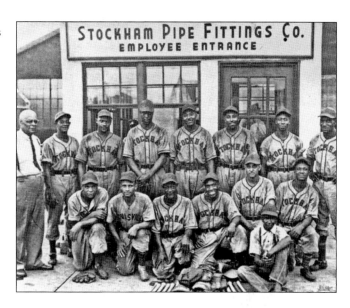

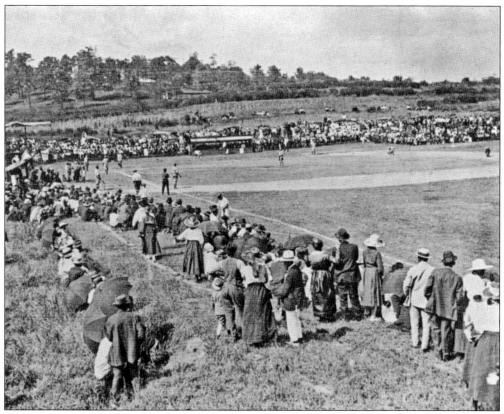

Weekend baseball games were not only for the male workers but became a social gathering place for women and children. Workers and their families, whether white or black, interacted with other iron industry employees through ball games. One player recalled, "When the white team would play, all the blacks would come—when the blacks would play, the whites would come."

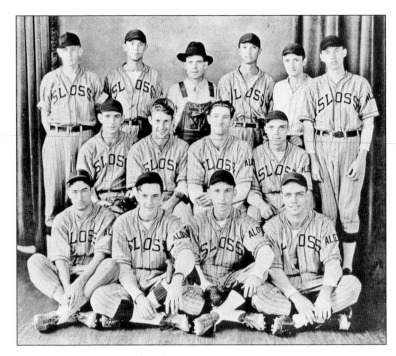

A 1926 Bureau of Labor survey of 431 companies revealed that 223 industrial companies reported one or more organized baseball teams in their plants. Seventeen of these companies were in the iron, steel, and mining business. Local iron and steel industries would frequently hire men "better known for their batting averages than their work records."

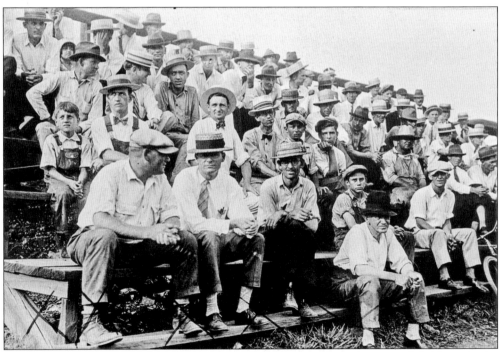

By the early 1900s, baseball was a Birmingham passion, especially with men and children. At the time, professional teams throughout the nation were drawing crowds of 60,000 daily. Birmingham's iron and steel industries embraced the sports and sent a number of talented black and white players to minor and professional leagues across the country.

Three

SLOSS-SHEFFIELD STEEL AND IRON

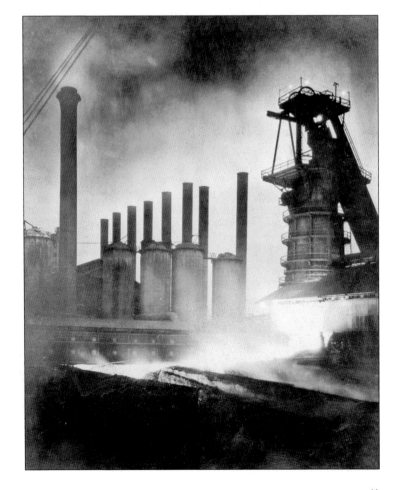

Coming off the heels of World War I, the Great Depression that began in 1929 was an extremely stressful time for the company. In October 1925, the directors of Sloss-Sheffield Steel and Iron, realizing they would never survive the Depression if they did not modernize, authorized $625,000 toward a massive rebuilding program.

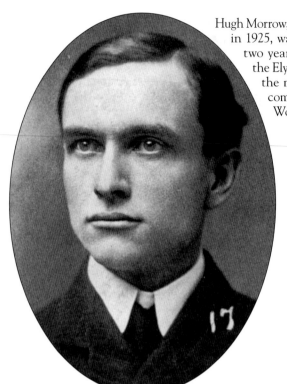

Hugh Morrow, who became president of Sloss-Sheffield in 1925, was born in Birmingham in 1873—only two years after the first lots had been sold by the Elyton Land Company. Morrow completed the modernization of Sloss and guided the company through the Great Depression and World War II.

Throughout the early 1920s, Sloss-Sheffield Steel and Iron remained a major producer of merchant pig iron. But by the end of the decade, the price of Birmingham pig iron had dropped to $16 per ton, and the company's net profit of $1,150,934 was down nearly half from the previous year.

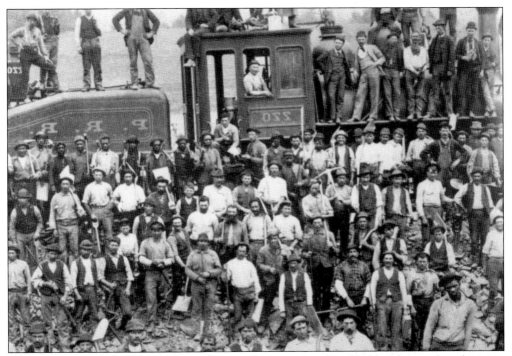

By the 1930s, nearly half the workers in Birmingham were employed by the iron, steel, and mining industries; more than two-thirds of the industries' workers were African American. Despite being dominated by black labor, the industrial workplace was rigidly segregated until the 1960s. At Sloss, as well as the majority of industrial site throughout the nation, men bathed in separate bathhouses, punched separate time clocks, and attended separate company picnics.

Sloss Furnaces, as did the majority of industries in the South, operated as a racially segregated hierarchy until the 1960s. At the top was an all-white group of managers, accountants, engineers, and chemists; at the bottom was an all-black labor gang. In the middle group of the Sloss hierarchy, a racially mixed group performed a variety of skilled and semi-skilled jobs.

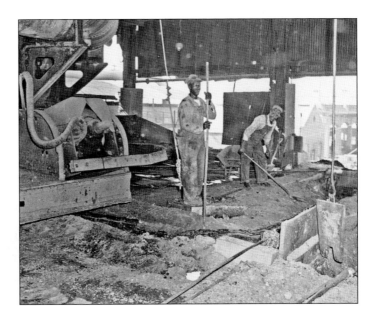

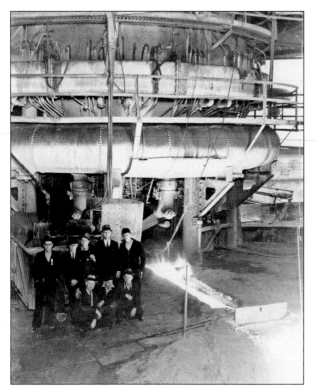

Between 1925 and 1927, the No. 2 Furnace was completely dismantled and reconstructed; the following year, the No. 1 Furnace was rebuilt. Each of the new furnaces had an average daily capacity of 400 to 450 tons, compared to a previous maximum output of about 250 tons. These innovative changes helped to push Sloss-Sheffield to the top of the world's pig iron producers.

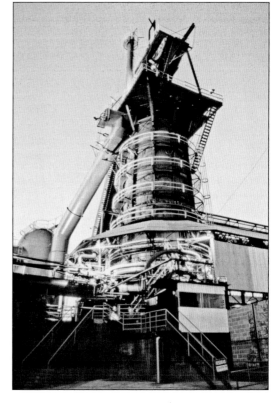

Extensively rebuilt and modernized in the late 1920s, the steel-jacketed furnaces were capable of producing twice as much as the original furnaces. Supported by cast-iron columns that were anchored in a concrete foundation lying deep under the surface of the ground, the installation was 82 feet higher than the original furnace.

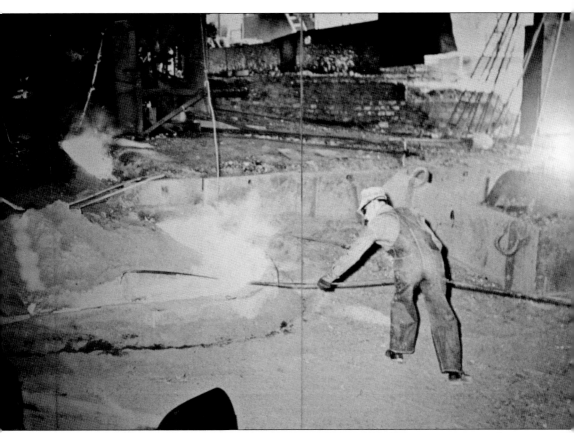

When heated, the ore, which ranged in purity from about 33 to 60 percent, separated into impurities and iron. While the dense iron sank to the bottom of the furnace, the lighter waste material, combined with molten limestone, formed slag, which floated above the iron. Slag was tapped every two hours into the sand beds of each furnace's cast shed. (Slag wool, a byproduct spun from blast furnace slag, was used for asphalt paving and in the production of ceiling tile.) Prior to the exclusive use of the pig-casting machine, molten iron flowed down hand-formed sand channels, or "sows," into several smaller channels to cool. The resulting shape resembled piglets suckling a sow, hence the product name, "pig" iron. Local foundries like Stockham, U.S. Pipe, and Hardie-Tynes were major Sloss customers, purchasing pig iron to remelt in their cupolas for processing into finished products. Birmingham foundry men cast the statue of Vulcan from Sloss No. 2 pig iron. (Courtesy of Bodin Morin and the Birmingham Historical Society.)

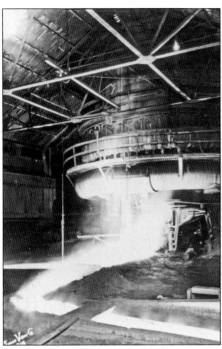

In the 1920s, Carl Carmer, a New Yorker and newly appointed professor at the University of Alabama, found Birmingham's industrial district overpowering, stating, "The valley of the furnaces is an inferno. Molten iron, pouring from seething vats, light the night skies with a spreading red flare. Negroes, sweating, bared to the waist, are moving silhouettes. On the top of a big mold they tamp the sand in rhythmic unison."

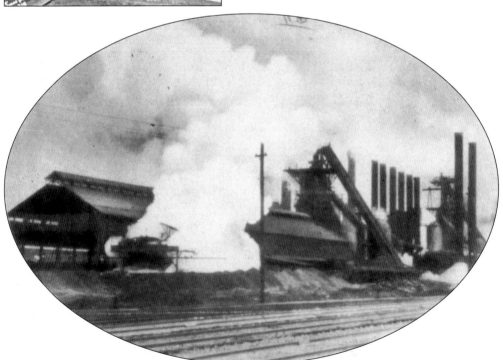

For 90 years, the Sloss City Furnaces made pig iron by melting iron ore in its furnaces fired with coke and vast quantities of heated air. Since the temperature of the furnaces reached 3,600 degrees Fahrenheit, the interiors were constructed of heat-resistant firebrick encased in steel plates. The exterior was cooled by water circulating through a system of pipes and water blocks inserted into the furnace lining.

The inclined Skip-Hoist hauled raw materials from the tunnel below the stock trestle to the top of the furnace. A system of steam-powered pulleys pulled two small skip cars up and down the incline. By the 1900s, Sloss supplied all of its own materials—iron ore, limestone, and coal.

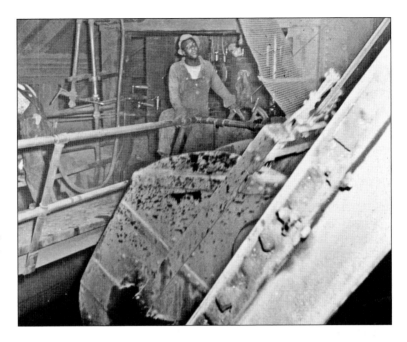

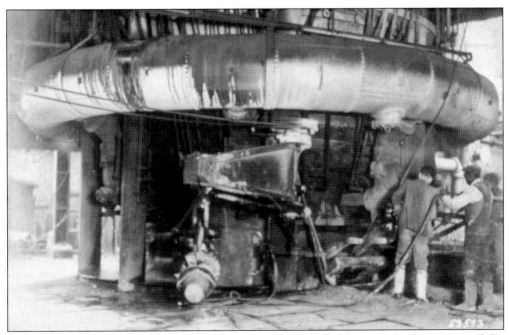

Birmingham's African American population grew dramatically beginning in the 1920s, and the majority of the men found work at one of the many Birmingham blast furnaces. Clarence Dean, who started at Sloss in 1937, stated, "You had to be on your 'p's and 'q's when you're working around a blast furnace. . . . All of it was dangerous—it wasn't no easy work for a black man."

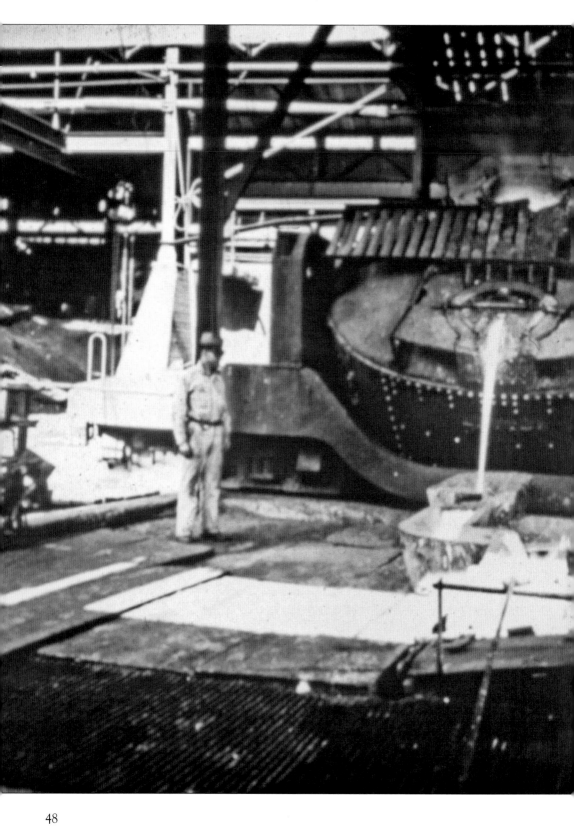

In 1931, Sloss-Sheffield installed an automatic pig-casting machine, greatly reducing the workforce at City Furnaces. Running through curved troughs from the furnaces into a 125-ton mixing ladle (located immediately outside the sheds that had previously been used for casting operations), melts of iron were poured into an endless train of individual pig molds, driven by a chain drive. A new skimming technique for removing excess graphitic carbon (kish) from machine-cast pig iron had also been developed by the time Sloss-Sheffield abandoned sand casting, satisfying the majority of their foundry customers unsure about the reliability of the newly installed pig-casting machine.

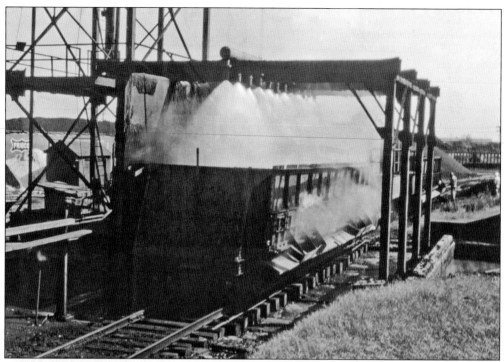

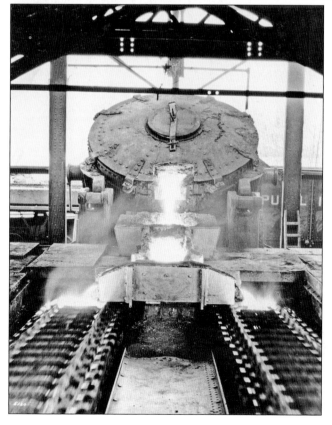

Cooling and solidifying as they traveled up an incline toward the automatic pig-casting machine, the finished pigs, weighing from 45 to 50 pounds each, were shaken loose as they reached the top and dumped into waiting railcars. This technique, which eliminated sand casting entirely, used equipment similar to that which Edward Uehling had invented in Birmingham in the 1890s.

The heart of the pig caster was the conveyor belt made up of shallow molds linked together. While it was in operation, workers often remarked that the conveyor belt reminded them of treads on an army tank. Surprisingly, until late in the 1920s, the only machine-cast pig iron produced by Sloss was its Etowah brand, made at its Gadsden, Alabama, furnace.

Edward Uehling was one of the two greatest engineers in the history of Sloss Furnaces. In 1895, he received a patent for an automated pig-casting machine that would revolutionize the iron-making process by vastly increasing production capabilities. Although Uehling offered this technology to Birmingham iron makers, the enormous capital investment placed the machine out of reach for Sloss and other Southern companies until the late 1920s.

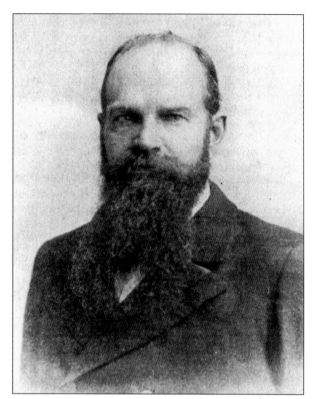

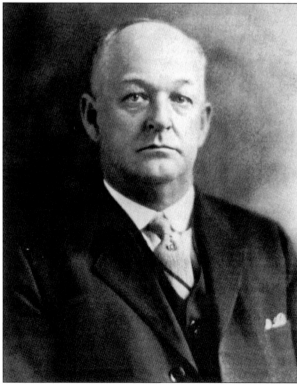

The second most influential engineer at Sloss was James Dovel. In 1925, Sloss-Sheffield appointed him vice president, and during his 21-year tenure Dovel devised many improvements to furnace construction. Inventions such as the self-renewing furnace lining and gas-washing apparatus were just two of his 17 patents that revolutionized the iron industry.

Pig Iron ROUGH NOTES

SLOSS *Spring* 1941

In 1926, recognizing the important role of mechanization in producing pig iron of a uniform quality, Sloss launched a quarterly, then monthly, publication titled *Pig Iron Rough Notes*. The publication served as a vehicle for the company to explain the improvements that mechanization provided to its customers.

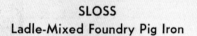

SLOSS
Ladle-Mixed Foundry Pig Iron

As Uniform as "Peas in a Pod"
UNIFORM IN SIZE AND IN ANALYSIS

Brand	Silicon	Sulphur	Phosphorus	Manganese
"Sloss"	1.25—5.00	.05 or less	.80— .90	.50— .75
"Clifton"	1.25—5.00	.05 or less	.70— .80	.60— .75
"Clifton"	1.25—5.00	.05 or less	.70— .80	.75—1.00
"Clifton"	1.25—5.00	.05 or less	.70— .80	1.00—1.25
"Noala"	1.25—5.00	.05 or less	.90—1.10	.60— .75

MACHINE CAST

All three brands are machine cast. "Sloss" and "Clifton" irons are made in Birmingham, using, as a base, red ore mined locally at Sloss mines plus a scientific blending of special brown ores from the district. "Noala" iron is made in Birmingham also, with red ore as a base, but using a much larger percentage of brown ores mined in the world-famous Muscle Shoals District of North Alabama. "Noala" has been known to foundrymen for over 35 years as the best Stove Plate pig iron in America. When mixed and melted properly it makes better heat-resisting castings and takes enamel perfectly.

In mining its own ores, Sloss is enabled to burden its furnaces with ores of such uniform analyses that regular and uniform furnace operation is insured. This, in turn, insures a high grade and uniform iron from each Sloss furnace at all times.

LADLE MIXED

All brands of Sloss Pig Iron have the additional and exclusive advantage of being thoroughly mixed in a specially designed 125-ton mixing ladle, as the molten iron discharges from the blast furnace. This exclusive Sloss feature results in every pig of each cast being absolutely uniform in chemical analysis. It is the UNIFORMITY of Sloss Pig Iron that keeps foundry casting losses down to a minimum.

Within a decade, the journal was being mailed to 5,000 readers. Despite its small stature, *Pig Iron Rough Notes* became one of Sloss-Sheffield's greatest contributions to the advancement of the foundry trade. Realizing that prominent foundry men would appreciate seeing their company's name in print, editor Russell Hunt devoted an article in every issue to a leading entrepreneur or facility associated with the foundry trade.

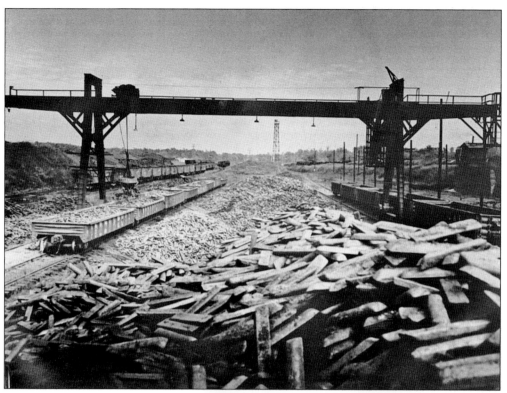

As Sloss-Sheffield's new furnaces, casting equipment, and scientific testing facilities developed, Sloss executives kept readers of *Pig Iron Rough Notes* well informed about the firm's latest technological achievements and how they contributed to producing the "best Foundry Pig Iron on the market."

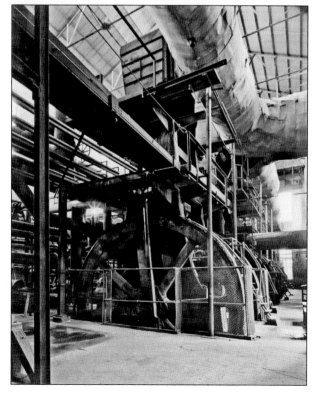

These vertical steam-powered blowing engines are some of the last in the world. When in operation in the early 1900s, the temperature of the enclosed engine house elevated to over 100 degrees Fahrenheit. They stand more than 30 feet tall and turned flywheels 20 feet in diameter. Just about every mechanical system at Sloss ran on steam—blowing engines, turbo blowers, skip hoists, and water pumps.

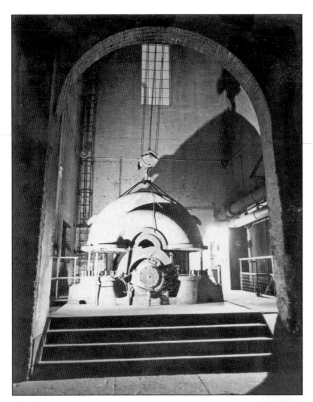

With the installation of two Ingersoll-Rand turbo blowers in the late 1940s and early 1950s, Sloss City Furnaces reached its pinnacle of technology. The two turbo blowers replaced the eight massive vertical blowing engines whose design was not much altered from the days when James Sloss first constructed his furnaces in the 1880s.

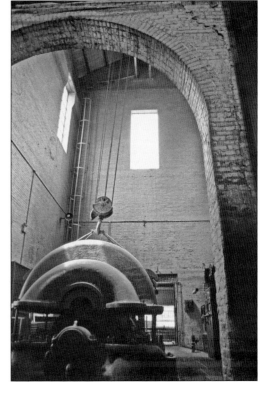

These innovative turbo blowers represented a giant leap in technology for Sloss Furnaces. By using radial motion rather than the old engines' reciprocating motion, the new turbines were more than adequate to operate the aging furnace. Installed between 1949 and 1950, the two compact, efficient turbo blowers did the work of all eight of the great steam engines.

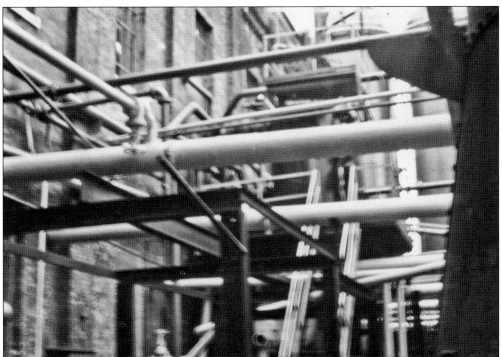

In addition to the powerful Ingersoll-Rand turbo blowers, an iron-making plant consisted of other important auxiliary machines and structures; stoves to heat the air, boilers to produce the steam, and a never-ending network of pipe that carried steam, water, and gas throughout the plant.

Cylindrical hot blast stoves heated the air pumped by the steam engines or turbo blowers. The stoves consisted of steel shells lined with heat-resistant brick and filled with a latticework of bricks called "checkers." Waste gases from the blast furnaces were burned in the stoves to heat the checkers. The gas was then shut off, and the air blast was blown through the stoves and then carried to the blast furnace.

In the 1880s, James Sloss chose to build his company on this land because of the existing Southern Railroad and L&N railroad lines. The raw materials were unloaded from train cars into bins beneath the trestle. There was a bin for coke, a bin for limestone, and bins for different grades of ore.

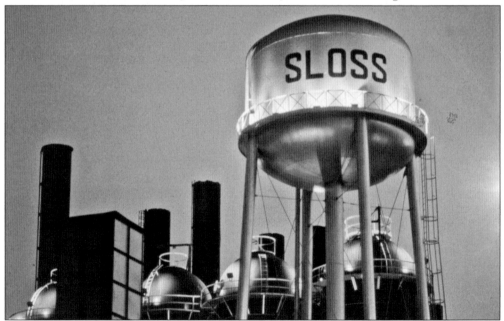

Although the furnaces contained a heat-resistant brick lining, water circulated through a system of pipes inside the bricks in order to keep them as cool as possible. Hot water exiting the furnace lining collected in a trough and was piped to a "spray pond," where it was cooled and recirculated. This process was crucial to furnace production, and Sloss pumped 5 million gallons of water a day through the system.

Steam was essential to the running of the furnaces. Steam powered the blowing engines and the turbo blowers that supplied the blast air. Steam worked the skip hoist and drove the generator that produced electricity for the plant. The boilers could burn coal and natural gas, but their primary fuel was the waste gas from the top of the blast furnace.

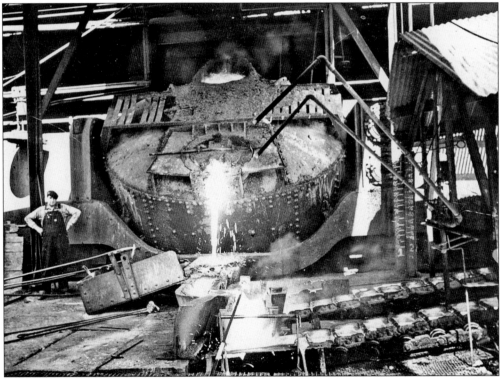

Although Sloss had a decent safety record, accidents did occur with regular frequency. Working around a blast furnace was extremely dangerous. On the casting floor, prior to the implementation of the automatic pig-casting machine, men working just inches from streams of molten iron were often burned and maimed. The implementation of the ladle car not only increased production but allowed for a safer work environment.

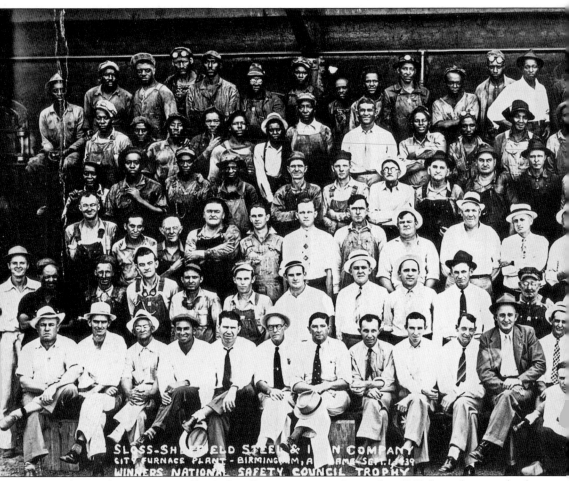

Workers and supervisors at Sloss's City Furnaces pose in September 1939 for a photograph after winning a trophy from the National Safety Council. With white supervisors in the front and black laborers in the back, the photograph reveals the segregation practices prevalent in all Southern industrial facilities in the 1930s. Regardless of race, prior to the implementation of industrial

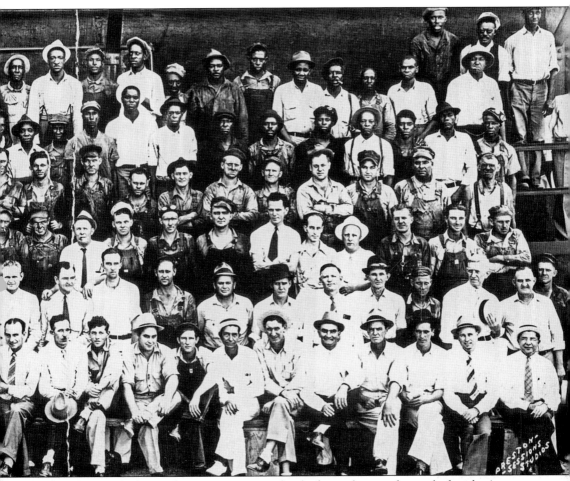

safety programs, the best safety insurance a worker had was the man he worked with. A new worker learned his job from his coworker, and each depended upon the other for warnings of unsafe conditions. Because of this "buddy" system and the closeness the work required, kinships developed among the workers.

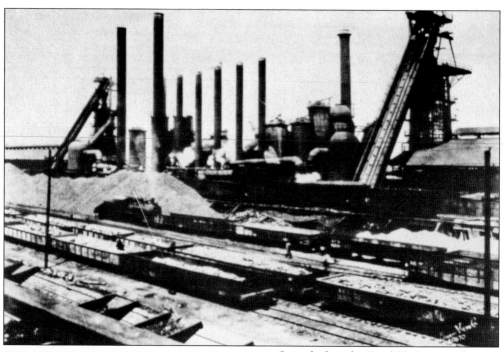

Long before the Pearl Harbor attack, *Pig Iron Rough Notes* was emphasizing the importance of cast iron to national defense. Under wartime regulations, Sloss fell under the jurisdiction of the pig iron unit of the War Production Board's iron and steel branch, which was charged with coordinating the output of approximately 3,000 foundries located throughout the United States.

SLOSS PIG IRON

Plays An Important Role In National Defense

In every section of the United States, cast iron foundries are turning out materials for national defense. In the cupolas of hundreds of them, we are proud to say, Sloss foundry pig iron is being melted for production of highest quality castings. When production problems arise in these same foundries, Sloss Shirt-Sleeve Service men get on the job with their practical knowledge of the foundry business.

To contribute all possible to the preservation of the American way of life, both at present and in the future, is the ambition of the—

Sloss - Sheffield Steel & Iron Company
Birmingham, Alabama

Virtually all of Sloss-Sheffield's output from 1941 to 1945 went into munitions. A sign in front of the City Furnaces stated, "This is a U.S Arsenal." The company took special pride in the number of company employees in the armed forces. A "Sloss Roll of Honor" included the names of 381 persons "serving on every front."

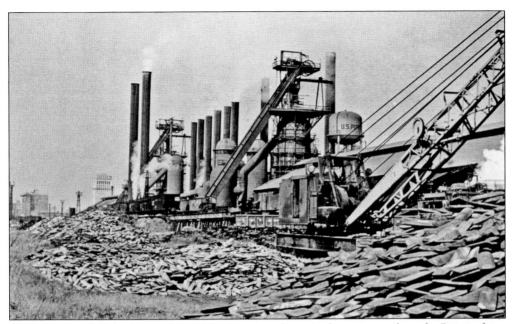

Sixty percent of all hand grenades used by American forces in the war came from the Birmingham area. Other defense-related items made by foundries included air compressors, brake drums, cylinder heads, and soil pipes for army bases. Although airplanes and ships were made largely of aluminum and steel, cast iron played a major role in the manufacturing process.

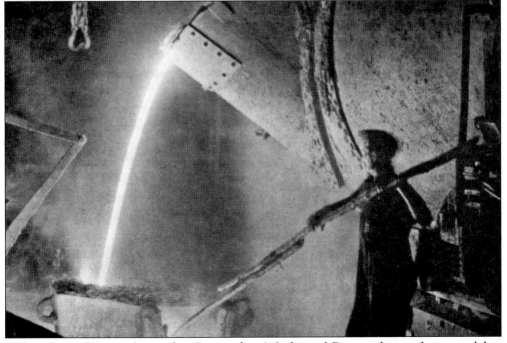

Although employment boomed in Birmingham's Industrial District during the war, a labor shortage from wartime demands created tensions between workers and plant managers. Despite a ban issued by the War Labor Board in 1942, sporadic walkouts took place on a regular basis. Sloss lost more than 421,000 man hours because of wildcat strikes.

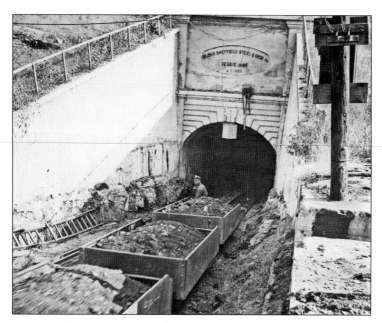

The Great Depression, which hit the nation in 1929, had a severe impact on Alabama mining operations. Production continued but did not fully recover until World War II, when demand for iron ore and coal greatly increased. Sloss No. 1 Mine, originally opened in the early 1880s, was the most productive mine and was eventually joined in 1890 by Sloss No. 2, which operated until 1959.

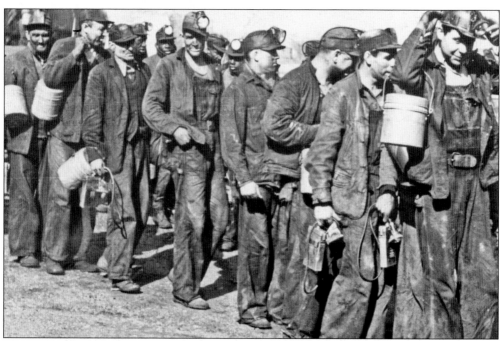

Alabama coal and iron ore miners engaged in a dangerous occupation made more difficult by hostility to union organization and strikes for better working conditions. Stubbornly opposing the drive to organize, companies like Sloss-Sheffield and Tennessee Coal and Iron created company unions in an effort to comply with federal regulations created during the Great Depression. However, despite company unions, intimidation, and armed force used by employers, the International Union of Mine, Mill, and Smelter Workers (IUMMSW) managed to organize Alabama's ore miners. Sloss-Sheffield's ore miners were the first in the state to affiliate with the union, forming Local 109 in July 1933.

For 70 years, the Sloss-Sheffield mines provided the majority of the red hematite iron ore for the blast furnaces of the Sloss-Sheffield Steel and Iron Company. Originally developed as sloped mines on the northwest side of Red Mountain, these mines overlooked the city of Bessemer, Alabama. The majority of Sloss red ore mines went out of production by the 1950s.

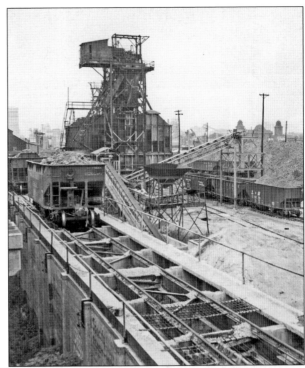

The Sloss-Sheffield Steel and Iron Company mines were part of a series of ore mines that stretched roughly 8 miles from Graces Gap to Readers Gap. This series of mines was capable of extracting over 8 million gross tons of ore per year. Alabama remained a top ore-producing state until the 1950s.

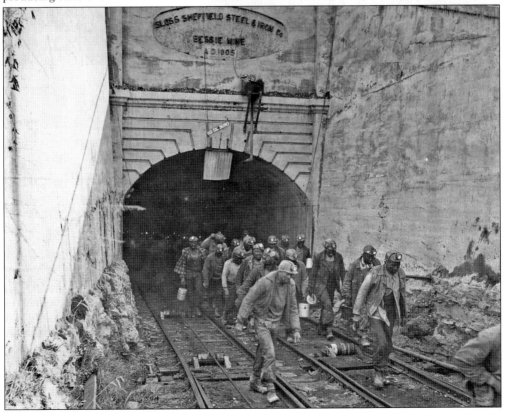

As early as 1914, slag, the waste product of the iron-making process, was being processed for conversion into cement and other building materials. Most of the early roads in Alabama used slag as ballast for the roadbeds. Vulcan Materials, a prominent international corporation in Birmingham, got its start in slag.

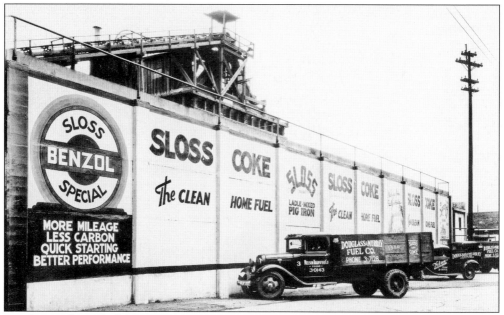

Besides supplying fuel from its coke ovens to the Birmingham Gas Company, Sloss-Sheffield produced benzene for motors and manufactured ferromanganese. It also created a quick-drying black aluminum-based paint used as a coating for pipe and fittings, as well as marketing a bug killer named DeaDinsecT after its main ingredient, DDT. This insecticide was a byproduct of xylol from the coke plant.

Income from Sloss-Sheffield byproducts was crucial in getting the company through the early years, when demand for pig iron was lowest. The Birmingham Gas Company bought fuel from the Sloss-Sheffield North Birmingham plant, whose surplus electricity was also used by the Alabama Power Company.

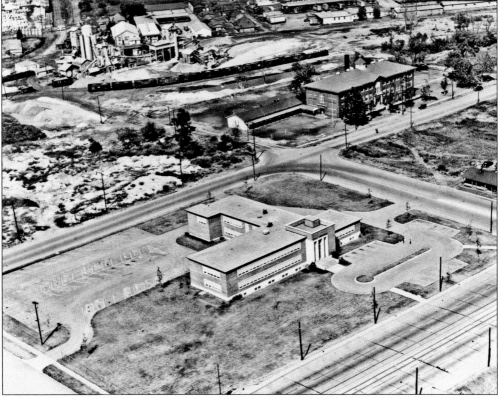

In 1952, Sloss-Sheffield merged with U.S. Pipe, and Claude Lawson, president of Sloss, became the new president of U.S. Pipe. A large office building was constructed near the City Furnaces (where Sloss Quarters had previously stood) to serve as U.S. Pipe's new corporate office. In the same decade, a new No. 5 Furnace was "blown" in at the North Birmingham site, with a capacity of 1,000 tons of iron per day.

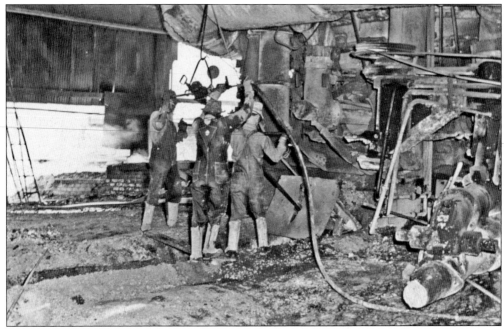

During the 1950s, the foundry industry continued to flourish, providing low-paying but nonetheless welcome job opportunities for blacks. By the 1960s, three out of every four whites were skilled, but only one of six blacks could claim such status. Forming nearly 35 percent of Birmingham's workforce, African Americans made up only 5 percent of the sales force and 7 percent of the managerial class.

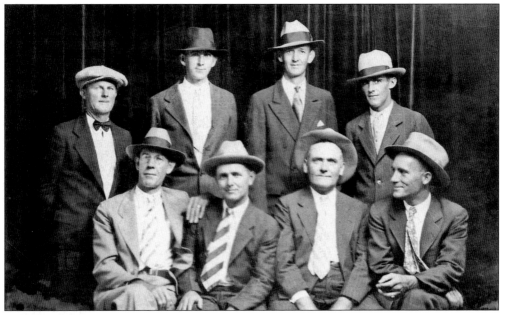

Despite pleas and educational campaigns conducted by national AFL-CIO union leaders, white members of Birmingham unions were determined to remain segregated. George Wallace's successful campaign for governor in 1962, following his pledge to maintain "segregation now, segregation tomorrow, segregation forever," owed much to his support from Southern white unions.

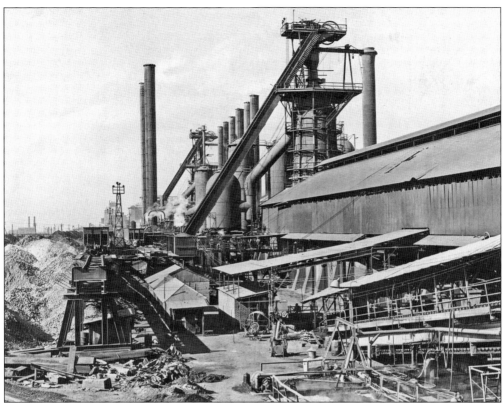

By the early 1950s, Sloss-Sheffield Steel and Iron was enjoying the highest profits it had posted in years. Net earnings for 1947 reached $22,359,000 while profits soared to $2,040,000. During each of the next two years, 1948 and 1949, sales topped $25 million, and earnings reached $2,639,000. In 1950, profits surged to an unprecedented $3,907,000.

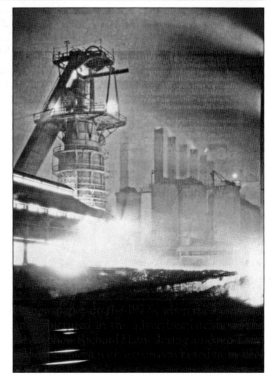

Throughout the postwar era, despite its much smaller size, Sloss-Sheffield consistently made better profits than its parent firm, U.S. Pipe. Local pipe works and foundries were still major purchasers of Sloss pig iron. During this time, due to the completion of the No. 5 Furnace, the older North Birmingham No. 3 and No. 4 Furnaces were dismantled.

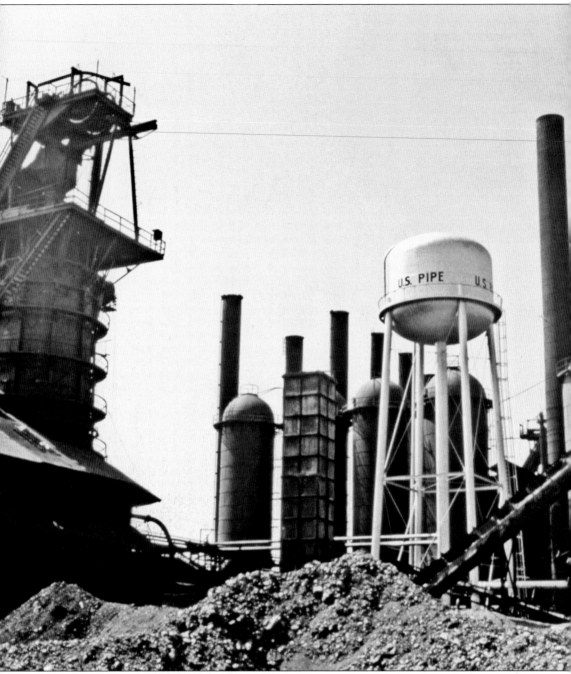

In the 1960s, technological advancements changed Birmingham's industrial landscape. Suddenly Sloss pig iron was obsolete. The introduction of ductile iron—an iron that combined the best features of iron and steel—made it the material of choice. And because of its low carbon content, foundries could use increased amounts of scrap iron instead of pig iron.

Four

END OF AN ERA

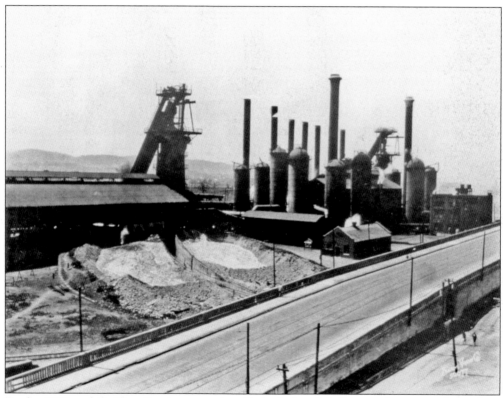

By the 1960s, while Sloss fought to survive all the industrial changes that were taking place throughout the country, a coalition of Birmingham civil leaders began communicating across racial lines to improve the city's tarnished image. By the mid-1960s, Clarence Dean, an African American worker at Sloss, had finally secured the promotion to iron pourer—a position he had requested for over 10 years.

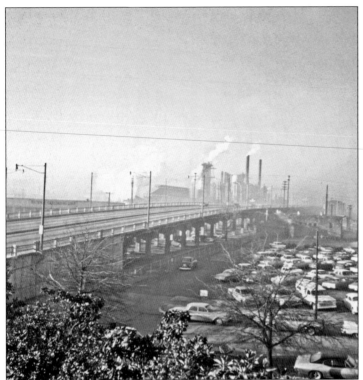

The Clean Air Act of 1970, as well as other stricter air pollution standards, contributed to the decline in Birmingham's iron and steel industry. American iron and steel plants were also beginning to face stiffer competition from foreign companies. Japanese plants started exporting low-cost iron and steel to American markets that were no longer protected by tariffs.

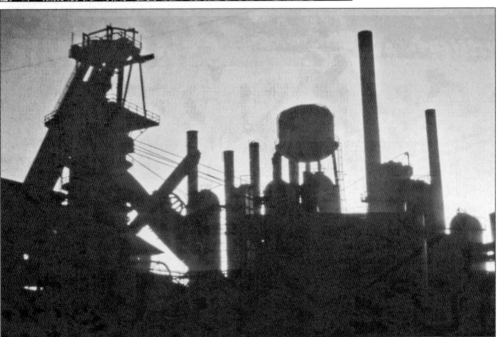

Early in 1970, the No. 2 Furnace was "banked," pending a major overhaul to replace its heat-seared lining and restore the hearth. The No. 1 Furnace, however, was operating at full capacity and continued to make money for U.S. Pipe. Nevertheless, by June 1970, it too went out of blast. After 90 years in operation, the blast furnaces at Sloss City Furnaces were silenced.

In May 1971, the Birmingham Convention and Visitors Bureau, along with other local organizations, submitted a proposal to U.S. Pipe stating that the Sloss City Furnaces be saved. Noting that the furnaces were "deep seated in the hearts of the community and carried historical significance," the proposal urged that the closed facility be converted into an industrial museum.

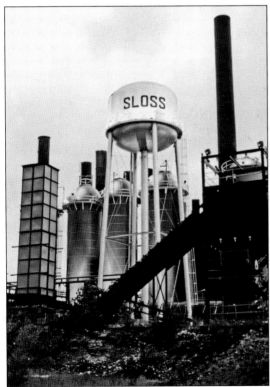

In 1971, the parent company of U.S. Pipe, the Jim Walters Company, decided that the Alabama State Fair Authority was the most appropriate recipient of the Sloss City Furnaces property. On June 1, 1971, a ceremony was held at the site and the transfer became official with a deed of gift transferring ownership from U.S. Pipe to the Alabama State Fair Authority.

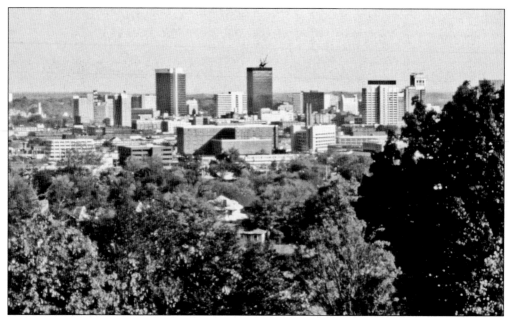

Birmingham's character changed dramatically during the 1970s. Sloss Furnaces had stopped production early in 1970, and by the end of the decade only 10 percent of jobs in Birmingham's industrial district involved iron and steel. Due to the growth of the University of Alabama at Birmingham, the city was now better known as an educational and medical center than an industrial city.

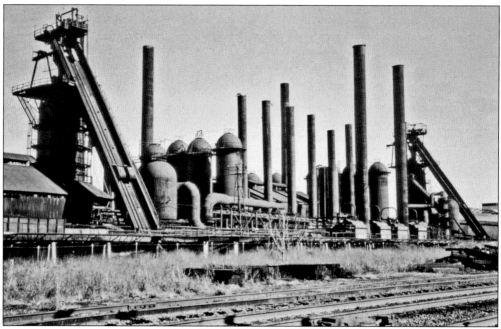

While Birmingham and the world around it changed, anger grew over what was happening with the land on which the idle Sloss Furnaces stood. U.S. Pipe had donated it to the Alabama State Fair Authority (ASFA), but for five years almost nothing was done. In June 1972, the site was placed on the National Register of Historic Places, but no funds were available for its development.

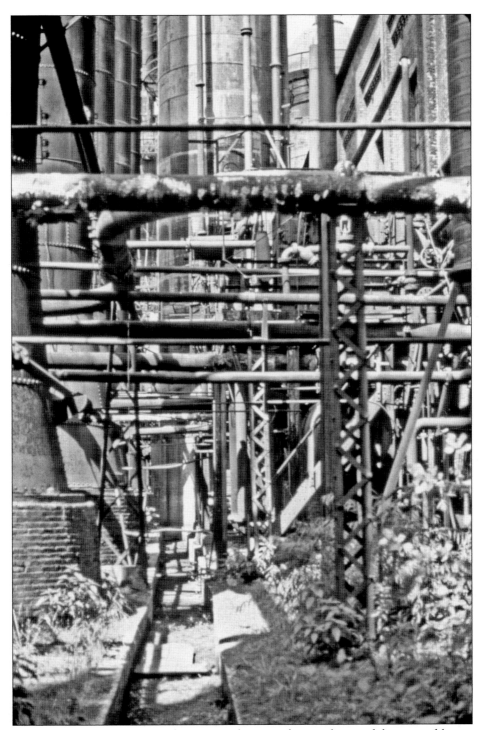

By the mid-1970s, vagrants were sleeping on the grounds at night, vandals removed brass and copper parts, and the plant became a Birmingham eyesore. Civic leaders talked about converting the site into a theme park, but nothing was done because the 18-acre location was too small and the projected $65-million cost was too high.

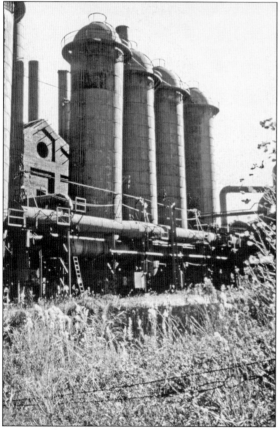

In 1975, the pig-casting machinery that had been installed in the early 1930s was sold to American Cast Iron Pipe Company (ACIPCO). For the most part, the rusting facility was left abandoned and ignored. Sloss Furnaces had become Birmingham's "white elephant." In March 1976, the City of Birmingham was advised to tear down the site because it was a "health and safety hazard."

In 1976, the Alabama State Fair Authority decided to tear down the furnaces, sell the debris for scrap, and put the land on the market for industrial development. Despite winning endorsement from the Birmingham Area Chamber of Commerce and a number of local businessmen, the plan aroused a storm of opposition across the Birmingham District.

Five

SAVING SLOSS

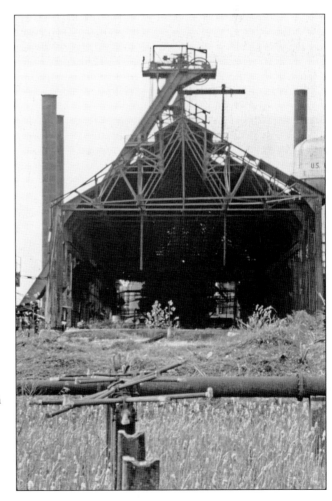

Determined to rescue the City Furnaces, Birmingham mayor David Vann and civic organizations throughout the area persuaded the Birmingham City Council to pass a resolution asking the Alabama State Fair Authority (ASFA) to delay action pending a survey by the National Park Service to determine what could be done to salvage the site.

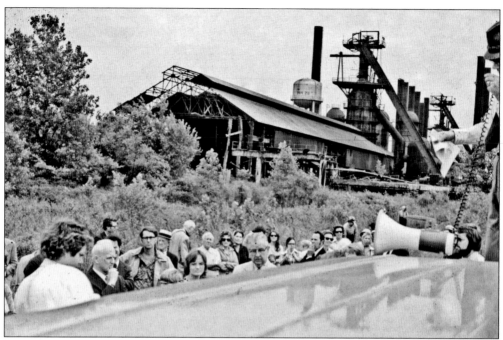

Still hoping to demolish Sloss, the ASFA organized a public tour of the facility to demonstrate its hazardous condition. But this effort backfired when, according to the Birmingham *Post Herald*, "Many of the 100 people who braved the mud, ants and threatening skies to make the tour, left with a resolve to fight to save the furnaces."

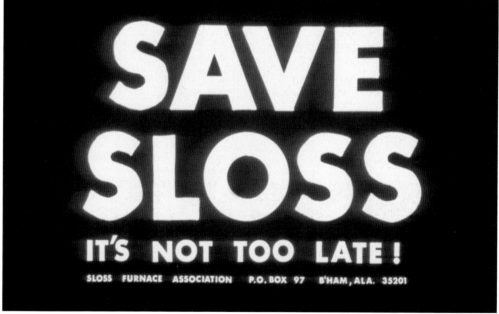

As the ASFA tour ended, a spokesman for the authority announced that plans for demolition would proceed on schedule. Local restaurant owner Randall Oaks denounced the move, asking members of the crowd to voice their opposition. Oaks and other concerned citizens called a public meeting at his restaurant and organized the Sloss Furnace Association (SFA). (Courtesy of Jim Waters.)

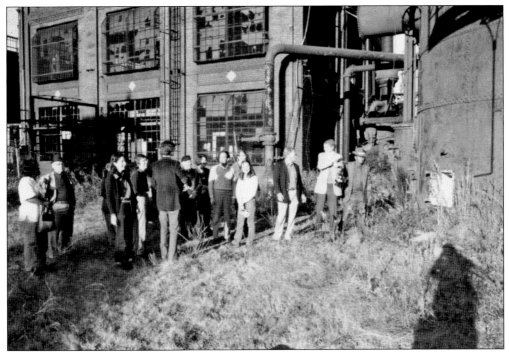

The original members of the Sloss Furnace Association included former Sloss employees, local businessmen, housewives, schoolteachers, doctors, an architect, and an engineer. They elected Randall Oakes as chairman and petitioned the city council to delay demolition until the issue received "further study." A survey of 36 city neighborhoods indicated that 29 wanted to save the furnaces. (Courtesy of Jim Waters.)

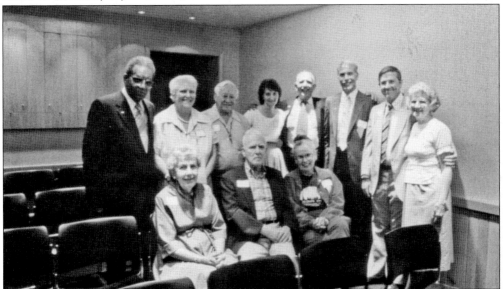

The founding members of the Sloss Furnace Association included, from left to right, (first row) Dottie Cavalleri, John C. Pugh, and Topsy Smith Rigney; (second row) retired Sloss worker George J. Brown, Margaret L. Cotton, E. E. "Dick" Cavalerri, unidentified, Paul S. Carruba, Randall Oakes, Jim H. Waters Jr., and Helen Mabry. (Courtesy of Jim Waters.)

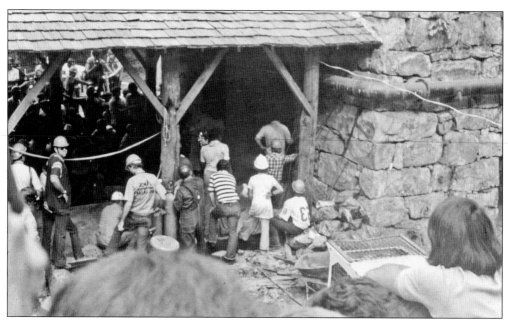

In 1976, with America celebrating its bicentennial, preservation interests were running high in Birmingham. At Tannehill State Park, the Fourth of July was observed by relighting the old antebellum blast furnaces, which had been repaired and restored. The Sloss Furnace Association, hoping to generate support for its preservation efforts of the old City Furnaces, organized a tour of Tannehill. (Courtesy of Jim Waters.)

In the summer of 1976, with the financial backing of the Birmingham City Council and the National Park Service, the Historic American Engineering Record (HAER) conducted a detailed survey of the Sloss Furnace property to assess its historical significance and prepare a permanent architectural record. (Courtesy of Jim Waters.)

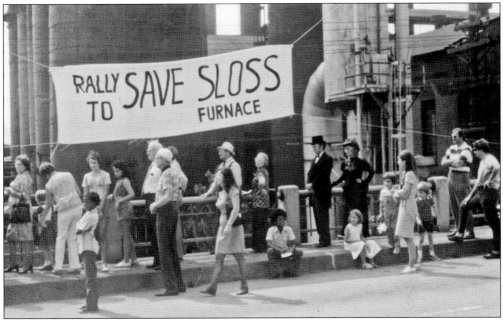

The "Save Sloss" parade crosses over the First Avenue Viaduct with Sloss in the background. A special meeting of the city council was called to hear some of the ideas developed for the preservation of Sloss. Proposals ranging from the creation of "ladle car rides" to a theme park similar to Disneyland were presented. Rejecting such visions as impractical, the State Fair Authority continued to press for its demolition. (Courtesy of Jim Waters.)

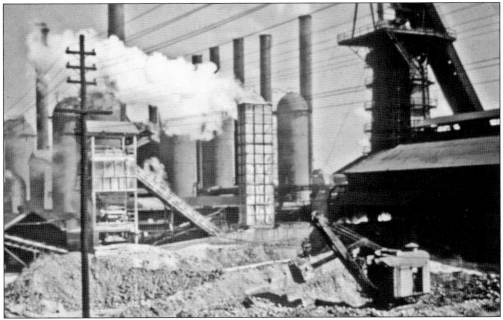

In 1976, U.S. Pipe and Foundry, remembering the furnaces during its glory days, conducted a study of its own and decided to donate $600,000 for restoration purposes. Their proposal called for repairing the No. 1 Furnace, the blowing engine building, cast shed, gas washer, loading bins, stock trestle, and stoves and destroying everything else. (Courtesy of Jim Waters.)

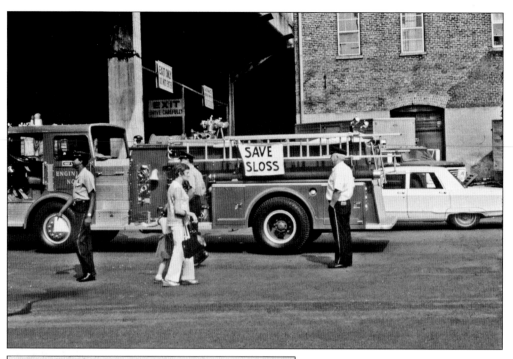

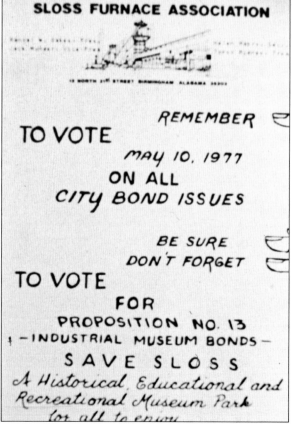

SLOSS FURNACE ASSOCIATION

REMEMBER
TO VOTE
MAY 10, 1977
ON ALL
CITY BOND ISSUES

BE SURE
DON'T FORGET
TO VOTE
FOR
PROPOSITION NO. 13
— INDUSTRIAL MUSEUM BONDS —
SAVE SLOSS
A Historical, Educational and
Recreational Museum Park
for all to enjoy

In 1976, dissatisfied with the U.S. Pipe proposal and determined to restore the entire site, the Sloss Furnace Association organized a fund-raising drive. Mailing lists were assembled, and newsletters were sent to prospective donors. A vintage car parade was organized, led by fire engines and covered by local radio and television stations. (Courtesy of Jim Waters.)

In 1977, noting that a projected $62.5-million bond issue would be submitted to voters for a number of projects involving outlays for schools and the public library, Mayor Vann persuaded the city council to earmark $3 million of this sum for refurbishing the furnaces and turning them into an industrial museum. (Courtesy of Jim Waters.)

Strongly supported and promoted by the Sloss Furnace Association, the proposition won approval by voters on May 10, 1977. Celebrating the outcome, the Sloss Furnace Association held a victory party at Oak's restaurant. In August 1977, the Alabama State Fair Authority turned over the title of the furnace tract to the City of Birmingham.

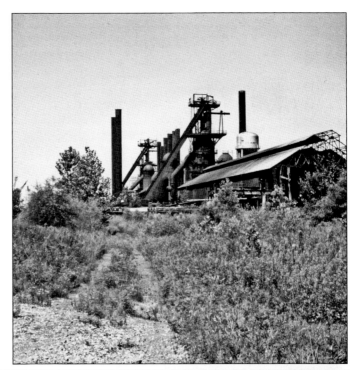

In a series of meetings at city hall, Jim Waters, a local architect and president of the SFA, outlined a plan to restore the site, the projected cost totaling $1,718,710. A group of outside experts, including Robert Vogel of the Smithsonian Institution's National Museum of History and Technology, visited Birmingham to support the plan.

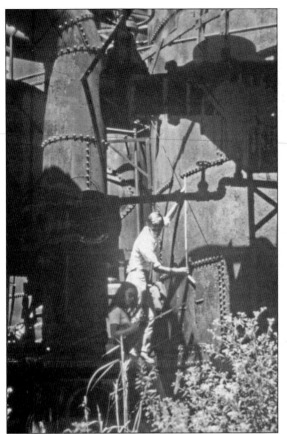

For more than 16 months, sandblasting and painting, grading and seeding, paving and lighting, removal or repair of hazardous structures, and renovation of the bathhouse (to be used as a visitors' center) proceeded. The SFA succeeded in having the site ready for the April 1982 celebration—commemorating the first run of iron that had flowed from the original No. 1 Sloss Furnace a century earlier.

In May 1981, the tract became one of only 87 sites in the United States to be designated a National Historic Landmark. Those participating in the ceremony included, from left to right, Robert M. Baker, Southeast Regional Office, National Park Service; Dwight L. Young, director, Southern Regional Office, National Trust for Historic Preservation; and the Honorable Richard Arrington Jr., mayor of the city of Birmingham. (Courtesy of Jim Waters.)

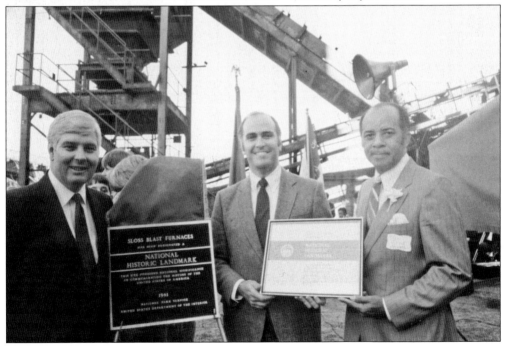

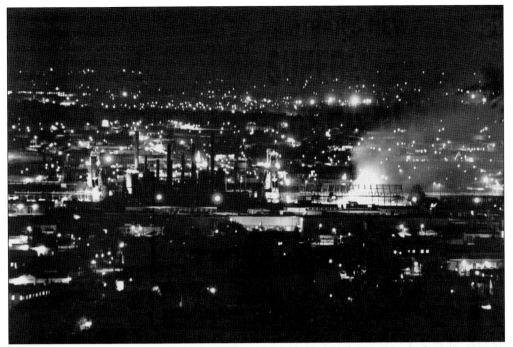

The evening celebration included a fireworks exhibition that had unintentional consequences. After all but two of the crowd had left the site, flames suddenly engulfed a wooden cooling tower. A motorist traveling on the Red Mountain Expressway noticed that "it was roaring with such force that it looked like the fire was being fed by a giant gas burner."

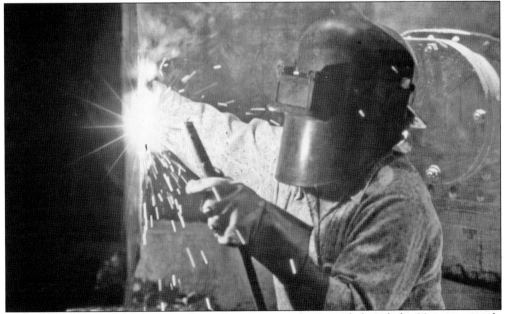

During the summer of 1982, a youth employment program provided work for 28 young people and two supervisors. The crew restored the stock trestle, rebuilt the elevated rail system that had once dumped raw materials into underground storage bins, and renovated the old service station where "Woco-Pep" had been sold to motorists in the 1930s.

Originally built in 1924, the Sloss Power House generated electricity for the plant. Steam from the boilers spun a turbine that powered a generator to produce alternating current. As shown in the photograph, the newly refurbished turbine and generator were housed on the upper level of the building, while the machines on the ground floor converted alternating current into direct current.

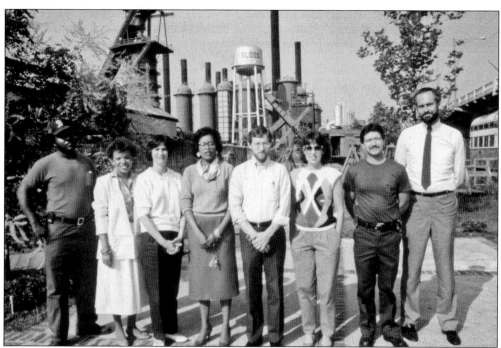

In December 1982, the Sloss Furnace Association and the city government appointed Randall Lawrence, who was completing his Ph.D. in American history at Duke University, as first director of Sloss Furnaces National Historic Landmark. Pictured here, members of one of the first Sloss staffs include, from left to right, Raymond Fleming, Sherrie Jones, Paige Wainwright, Barbara Nunn, Robert Casey, Virginia Shirley, Matt Landers, and executive director Randall Lawrence.

In August 1983, Randy Lawrence took reporter Elma Bell up a catwalk to the top of the gas washer to get a panoramic view of the site. Years before, Bell's grandmother had taken her to see the furnaces in operation to give her a warning of what hell would be like if she misbehaved. After surveying the scene below her, Bell wrote that the "magic of the place finally hit me."

On Labor Day weekend 1983, four days of opening festivities began when the Birmingham Heritage Band gave a jazz concert in the casting shed amphitheater. Over 500 people attended the performance. As vocalist Sheryl Goggans sang "Birmingham, Birmingham, This is my Home" under pink stage lights, listeners enjoyed wine and hors d'oeuvres.

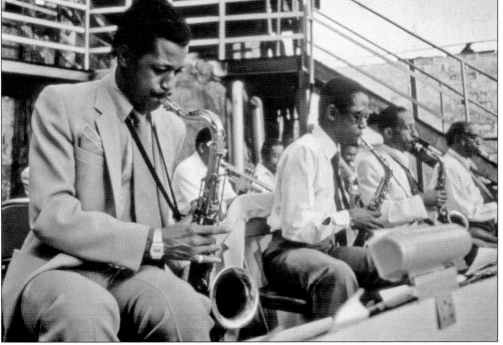

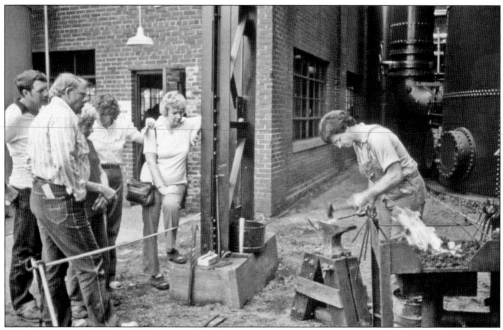

Guided tours of the newly refurbished site were offered by retired workers and Sloss staff members. A variety of musicians wandered the site entertaining visitors, while a blacksmith from Tannehill State Park gave a metalworking demonstration in the plaza under the water tower. In the evening, a bluegrass concert ended the day's festivities.

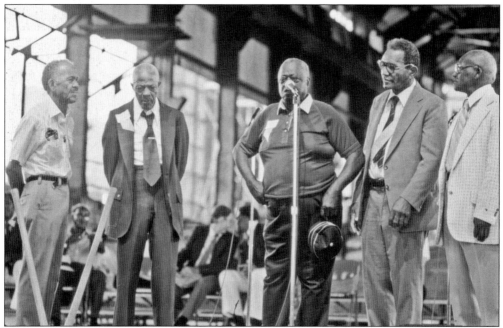

The four-day celebration at Sloss Furnaces National Historic Landmark reached its climax on Labor Day, September 2, 1983, with three hours of activities honoring former furnace employees. Included on the program were performances by the Birmingham Community Band, the Sterling Jubilee Singers, and the Delta Aires. Hundreds of people came to celebrate the closing ceremonies.

Visitors not only enjoyed the concerts, demonstrations, tours, and various other activities and events, but they were awed by the site's "resurrection" from obscurity. No longer residing under a cloud of smoke and soot, the furnaces welcomed the curious and those anxious to explore its acres of newly refurbished stacks, stoves, and network of pipes.

Although most of the repairs and restoration had concentrated on the furnaces, stoves, and blowing engine building, the former bathhouse had been converted into the Sloss Visitors' Center (left side of the photograph). For the Labor Day opening, local historians had arranged a gallery of photographs pertaining to coal mining, iron manufacturing, and railroading. Offices were later added for Sloss staff.

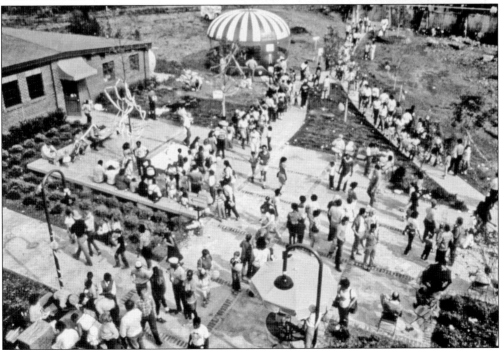

Former Sloss employees, some of whom had worked for the company for more than three decades, were recruited to serve as tour guides and provide historical accounts of what it was like to work at Sloss Furnaces. George Brown (seen here), member of the Sloss Furnace Association and former Sloss employee, began working at Sloss in the late 1920s. He said, "I made 32 cents an hour. I fired those boilers for them for twelve years."

Tours and lively conversations with former Sloss workers were an important part of the four-day celebration. Workers, elated that the old site was restored, were eager to tell their stories and reminisce about the past. Educated tour guides explained the iron-making process and the site's significance to Birmingham's industrial history.

Six

PRESERVING THE HERITAGE

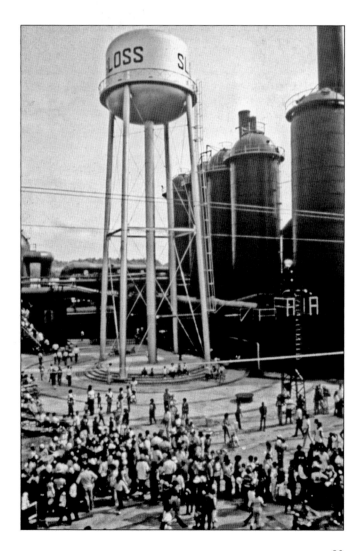

In 1983, an editorial in the *Birmingham News*, entitled "Sloss Stirs Again," stated that Randall Lawrence and his staff had rekindled a fire in the historic facility, "It is not the coke-fed blaze of a blast furnace which animates the old mill this time—it is the bright spark of community involvement."

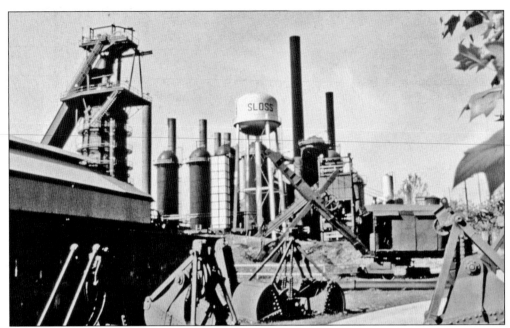

Since the induction of Sloss as a National Historic Landmark in the early 1980s, the mission at Sloss has stayed the same—preservation, interpretation, education, and development. Equally important, Sloss acts as a cultural resource by being a center for community events, civic life, and the creation, display, and interpretation of metal arts.

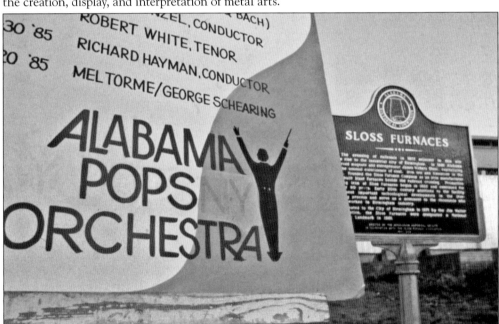

Today Sloss is not only dedicated to preservation and education but also serves as a center for community and civic events such as rock concerts, theater performances, music festivals, food festivals, weddings, and reunions. Public presentations, lectures, and site tours provide insight into the site's industrial heritage, as well as a rare glimpse of an earlier Birmingham that has all but disappeared.

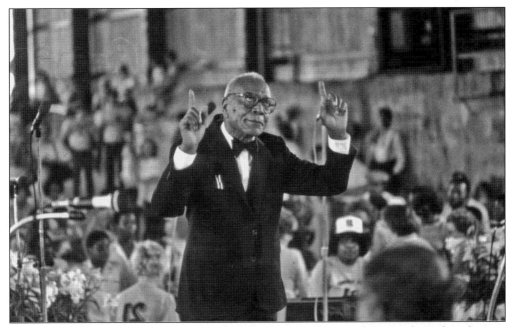

Theater groups, dance troupes, and a multitude of musical groups have performed in the cast shed under the shadow of the No. 1 Sloss Furnace. Where else can one hear classical music or rock accompanied by the sound of a nearby train whistle? Capable of seating over 2,000, the cast shed is booked year-round for a variety of programs and performances.

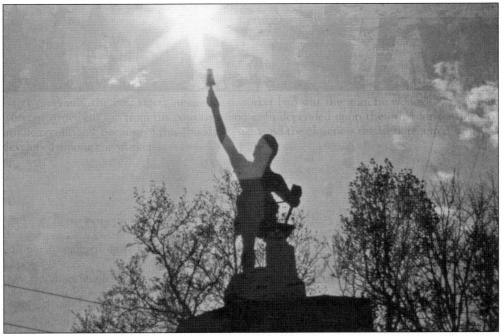

Sloss collaborates with Vulcan Park and Museum, as well as other local institutions and museums, on activities ranging from educational programs to metal arts exhibits and historic presentations. Vulcan Park and Museum was completely restored in 1999 and still provides a panoramic view of the city below, including Sloss Furnaces.

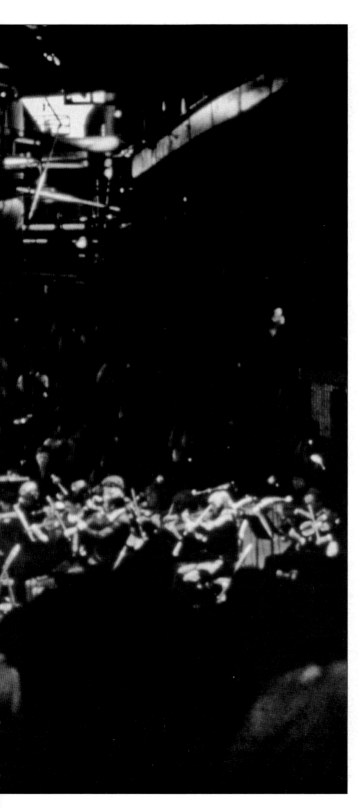

Much of the effort of the Sloss Furnace Association was aimed at encouraging visitors and Birmingham residents to look upon Sloss Furnaces as an appropriate place for public gatherings and events. The highly regarded Alabama Symphony Orchestra gave its first concert in 1983 at the inaugural Labor Day festival. The orchestra can trace its beginnings back to 1921, when 52 musicians joined together to perform at the Birmingham Music Festival. In 1933, the Birmingham Symphony Association was officially formed and J. J. Steiner was installed as president. With a budget of $7,000, four concerts were planned for its first season. In 1976, due to its popular support throughout the state, the symphony changed its name to the Alabama Symphony Orchestra. The symphony, like Sloss Furnaces, continues to be an integral part of the cultural landscape of the state.

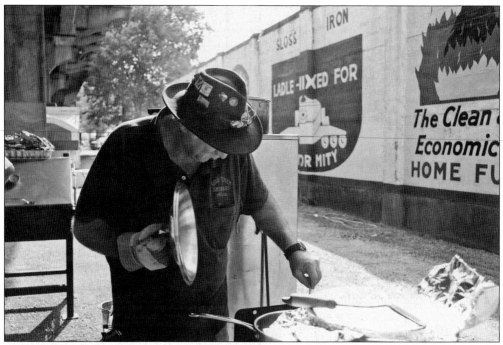

Sloss Furnaces National Historic Landmark hosted its first Stokin' the Fire BBQ and Music Festival in August 2004. At the cornerstone of the two-day family festival is a barbeque competition sanctioned by the world-renowned Kansas City Barbeque Society. The competition brings in barbeque cookers from all over the country vying for a variety of cash prizes and trophies.

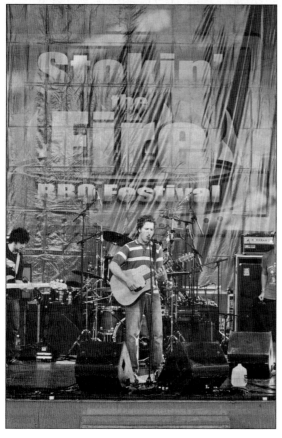

The Stokin' the Fire BBQ and Music Festival offers something for everyone. In addition to the "BBQ battles" featuring competition in the two categories of chicken and pork, visitors enjoy headliner music groups and grilling demonstrations by some of Birmingham's best restaurants. Sloss Furnaces, where a majority of the nation's "pig" iron was once manufactured, is an ideal location for the event.

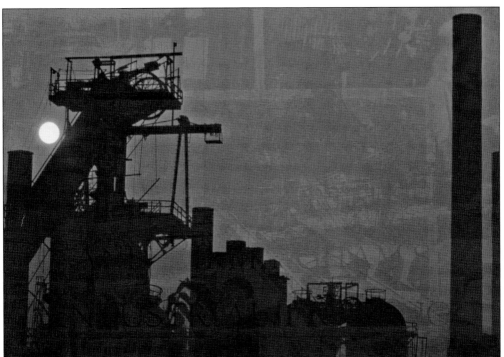

The numerous festivals and events held under the towering furnaces and majestic stoves are a reminder to the citizens of Birmingham that Sloss Furnaces serves not only as a historic symbol of Birmingham's industrial past but also as a museum and a community center. Sloss Furnaces is more than a landmark or museum—it presents the character and spirit of the South's industrial heritage.

From the outset, those involved in the restoration of Sloss Furnaces National Historic Landmark viewed the museum not merely as a place for public gatherings but as a center for research and educational purposes. Since its opening in 1983, hundreds of thousands of children have visited and toured the immense blast furnaces and lofty smokestacks—not only to learn about the production of pig iron but to have fun as well.

Local youth organizations, including the Boy Scouts and Cub Scouts of America, occasionally hold meetings and conduct a variety of projects on the museum site. Over the years, local Scout organizations have assisted the site in a number of activities, including the painting of a donated railcar. These projects and events enable the youth of the city to develop an appreciation of Birmingham's rich industrial past.

Sloss educators and curators host workshops and classes for local and national academic institutions. Photography and architectural classes visit Sloss on a regular basis to study and photograph the site's complex industrial structures. Visiting art classes sketch the majestic furnaces and intricate web of pipes and equipment housed in the blowing engine building. Naturalists study the site's unique urban wildlife and foliage.

Although Sloss Furnaces does not conjure up images of an ideal natural environment, since its closing, plants and animals have made their homes throughout the site. Slag pits and coal piles support clumps of foxtail, primrose, and sweet clover. Ferns cling to the cool, damp brickwork along the old boilers, and small mammals find an abundance of food in the vegetation of the open fields.

Educational outreach programs focusing on the lives of Sloss workers leave students with a true sense of what life was like in a 1900s Southern industrial town and how facilities like Sloss impacted the growth of Birmingham's industrial district. These innovative programs bring history alive for students by giving them a greater understanding and appreciation of what life was like for early workers.

A popular outreach program with the local schools is "Little Red." Little Red, dressed in faded overalls and a bright-red bandana, visits local classrooms around the Birmingham area and brings to life the work experiences and stories of what it was like for an African American worker at Sloss in the early 1900s. Ron Bates, Sloss Museum assistant, has been portraying the Little Red character since the 1990s.

Sloss Furnaces offers a variety of programs for children, including a kids club called the Future Furnace Keepers. The FFK membership not only offers children the opportunity to participate in a variety of Sloss activities, but it teaches children the history of Sloss and the impact the site had on the development of Birmingham's industrial past.

Educational programs allow visiting school groups to design and create their own cast-iron tiles using trivet-sized sand molds ("scratch blocks"). Students watch while Sloss artists melt scrap iron in a small furnace and fill the completed sand molds. As the metal cools, it hardens into a cast-iron tile, and within moments students take away an original work of art. Education coordinator Kimbellee Fipps explains scratch-block designs.

Innovative educational programs not only allow for creativity but introduce students to the history and significance of Sloss Furnaces and Birmingham's industrial heritage. Students of all ages discover that the area where Sloss and its idle furnaces now sit was once a rural cornfield, surrounded by forest. And in the nearby hills, just beyond where these children are standing, were rich deposits of coal, iron ore, and limestone—all the necessary materials needed for making iron and steel—and all found within a 30-mile radius of the site. A large majority of the students visiting Sloss Furnaces had grandfathers, uncles, or other relatives once employed by one of the many blast furnace sites located within Birmingham's industrial district. Sloss Furnaces National Historic Landmark is the last remaining furnace of its kind and stands as a testament to the thousands of workers responsible for Birmingham's great industrial boom.

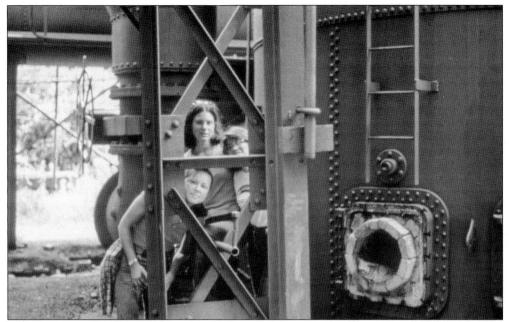

The enormous size and complexity of the site amazes children and adults alike. About two-thirds of the historic structures were stabilized using the bond funds approved by the Birmingham voters in 1977. Guided tours and a variety of educational programs allow visitors to appreciate the intricate structures and to understand the production elements of the iron-making process.

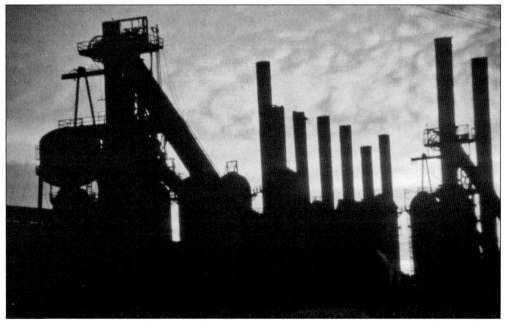

Alabama folklorist Kathryn Tucker Windham observed, "The towering stacks of Sloss Furnaces stand silent guard over batches of memories of how things used to be, of sweating men silhouetted against the flame, of skip cars dumping their loads of ore, coke, and limestone into the ravenous furnaces, of sparks scattering skyward like millions of shooting stars." (Courtesy of the Birmingham Historic Society and Kathryn Tucker Windham.)

Once a year, Sloss Furnaces hosts a "Ghost Tour" based on a story written by Alabama folklorist Kathryn Tucker Windham. *The Ghost in Sloss Furnaces* is based on a true story about Theophilus Jowers, a young Birmingham iron worker who "died a fiery death" in a furnace accident at the Alice Furnaces in the late 1880s. (Courtesy of Melissa Pardi.)

During the Ghost Tour, visitors are guided through a candlelit path and stop at different Sloss structures to encounter "ghostly" inhabitants eager to share their stories of pain and misery. Sarah Jowers, Theo's wife, tells the visitors, "Theo always said he would never leave the furnaces, and it looks like he was speaking the truth. I never thought it would be like this."

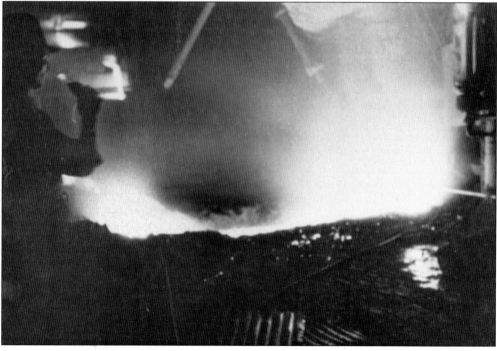

Following the untimely death of Theophilus Jowers, a local newspaper printed an article entitled "A Horrible Death, A Workman Falls into Alice Furnace." The article stated, "Jowers had hold of a rope—and was standing close to the top of the furnace, when by some mishap he tripped, and went tumbling down into the fiery furnace. The intense heat reduced his body almost to ashes."

The article, printed in the Saturday morning edition of the *Birmingham Age*, dated September 10, 1887, also stated, "A piece of sheet iron was attached to a length of gas pipe, and with that instrument his head, bowels, two hip bones and a few ashes were fished out. Two workmen who were on the bridge with him came very near going in."

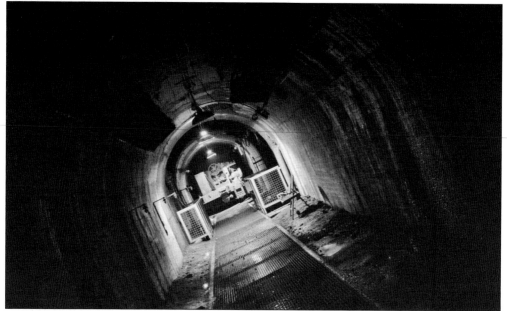

Visitors listen to stories told by "ghost" workers as they are guided through the eerily quiet Stock Trestle Tunnel. While Sloss was in production, raw materials for the furnace came in by railroad car to the elevated stock trestle. Doors on the bottom of the cars dumped the materials into bins below the trestle. (Courtesy of Melissa Pardi.)

During the 1980s, Kathryn Windham, author of over 14 books, made frequent trips to the Sloss amphitheater stage for a late-night "telling of tales," including that of Theophilus Calvin Jowers. Windham's book continues to be a best-seller in the Sloss Museum store and is the basis for the museum's yearly Ghost Tour.

In 2005, Elizabeth Hunter, New York screenwriter and theater director, moved to Birmingham and was immediately captivated by the enormity and uniqueness of Sloss Furnaces. While most visitors appreciate Sloss for its historic significance, Hunter saw it as the perfect backdrop for Shakespearean theater. Elizabeth Hunter's Muse of Fire project is now a regular mainstay at Sloss and brings in hundreds of visitors each year.

The Shakespeare at Sloss project not only brings in visitors familiar with Sloss Furnaces National Historic Landmark, but artistic performers and theatergoers who normally would not visit an industrial museum. Following a Sloss Muse of Fire performance, many audience members often return to the site to learn about its historic significance. Some of the performances staged at Sloss include *Macbeth*, *Hamlet*, and *A Midsummer Night's Dream*.

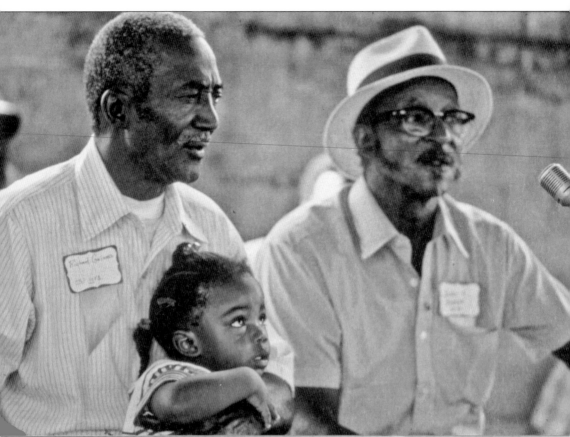

Since its opening in 1983, Sloss staff members have been actively collecting oral histories. The majority of these histories are from black and white workers who speak not only to the technological aspects of the facility but also to what life was like working in the midst of a fiery blast furnace. Oral histories gathered from men and women residing in Sloss Quarters provide valuable insight into the social activities and events of life in a company town. While their husbands toiled and labored in the blast furnaces, and while faced with the sting of segregation and discrimination, these remarkable women built strong and lasting family foundations by adapting their rural customs and traditions to their new surroundings. Sloss Quarters did not become the cohesive community because of the men who worked at Sloss Furnaces; it thrived and succeeded because of the women who were determined to make a better life for their families.

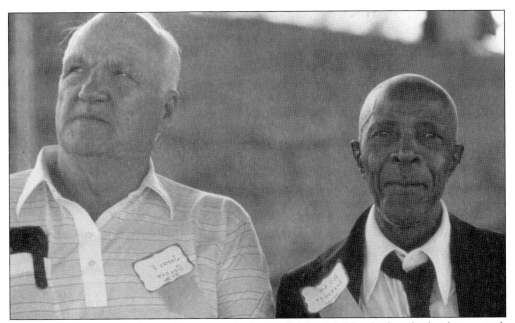

Sloss Furnaces was a leader in the iron-producing industry and, like the hundreds of iron, steel, and textile plants scattered throughout the industrial South, had a culture all its own. The Sloss oral history collection speaks to the dangers and responsibilities of working in the midst of a fiery blast furnace as well as to what life was like outside the plant.

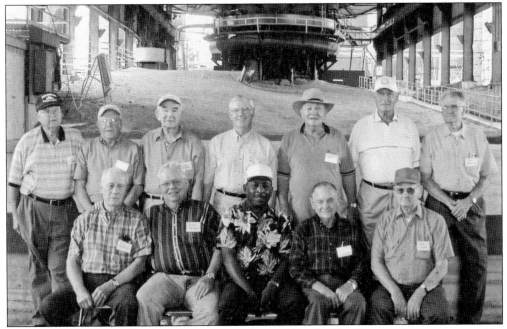

The gathering of these remarkable stories, originally started by the Sloss Furnace Association, provides a glimpse into the working lives of hundreds of retired Sloss workers. Over the years, machinists, burden clerks, foremen, and furnace keepers have shared their stories, as well as chemists, doctors, boilermakers, powerhouse operators, welders, electricians, and granulator operators. Retiree reunions held twice a year bring workers back together to reminisce and relive the past.

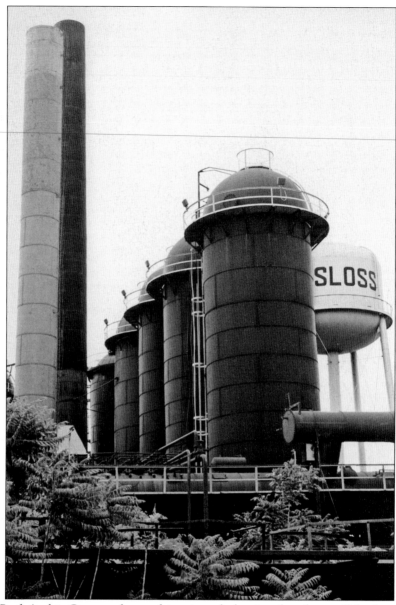

In 1986, Prof. Archie Green, a famous historian of what is referred to as "laborlore," came to visit Sloss Furnaces. Dr. Green, a man who dedicated the majority of his professional life to the documentation of the lives of working people, was not only impressed by the towering furnaces and impressive stoves, but he began to wonder about the men who had worked in the many blast furnaces and mines scattered around Birmingham's Industrial District. He questioned how these men—men who helped to make America an industrial powerhouse—survived this type of dangerous and demanding work. In 1994, realizing the role music played in the working lives of Southern American migrants, Dr. Green decided to collaborate with a group of music scholars and folklorists to catalogue and preserve the songs, the lyrics, and the ballads that were an important part of the lives of these determined people. What was to come out of this collaboration was a remarkable education tool entitled *The Spirit of Steel: Music of the Mines, Railroads and Mills of the Birmingham District.*

Some of the first workers interviewed for the *Spirit of Steel* book were African American railroad workers known as "gandy dancers." These section crews did what was considered the most physically demanding jobs on the railroad, including realigning and straightening sections of track. The task was done by using 20-pound, 5-foot-long lining bars made of steel. The timing of each man's pull was crucial, and to keep everyone on track and everyone synchronized, a "caller" would lead the men in a "chant." These chants not only ensured the correct alignment of the track, they also made the work less tedious and more uplifting. A 1988 reunion of the retired gandy dancers was followed by a performance at the Alabama Folklife Festival and a documentary film, *Gandy Dancers*, was produced by Maggie Holzberg and Barry Dornfield. A group of gandy dancers performed at the Sloss Labor Day opening in 1983. (Courtesy of Maggie Holzberg, Joey Brackner, and Paige Wainwright.)

In 2009, Sloss Furnaces inherited a vintage 1917 Frisco steam locomotive that had been at Birmingham's Fair Park since 1952. The locomotive, Engine No. 4018, ended 33 years of service in February 1952 with Frisco Railways. Steam locomotives played an important role in Birmingham's development because it was one of the few industrial centers in the nation that did not have access to water transportation.

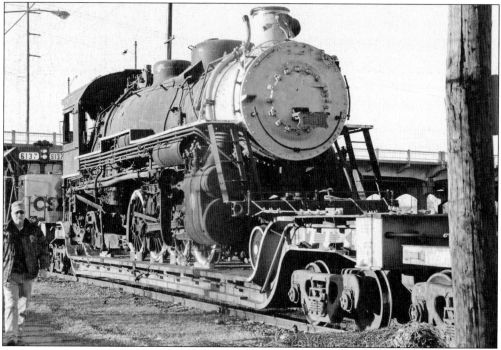

The labor-intensive move was spearheaded by Terry Oden, mayor of Mountain Brook, Alabama, and assisted by Bob Yuill, a heavy-machinery restoration expert. CraneWorks, a local heavy-equipment company, supervised the move of the 400,000-pound engine, along with technical and safety experts from various departments within the City of Birmingham.

Seven

SLOSS METAL ARTS

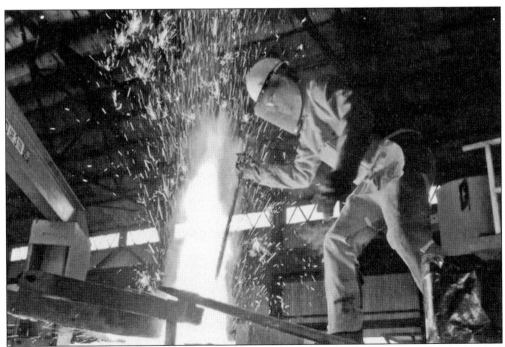

Sloss Furnaces is home to an innovative and active Metal Arts program that has a national reputation as a vibrant center for artists who work in cast iron. The program addresses all aspects of creating metal sculpture, including pattern making, casting, welding, and forging. The Metal Arts generates supporting revenue and receives generous funding from the City of Birmingham, the Alabama State Council on the Arts, and the National Endowment for the Arts.

Before metal casting became part of the Sloss Metal Arts Program, blacksmithing was the main art form. Besides offering classes, the Metal Arts Program hosted an annual festival, which included workshops led by nationally known artist-blacksmiths that was followed by a juried exhibition. This ornate steel box was designed in 1987 by blacksmith Tom Latane of Wisconsin and the Birmingham Blacksmithing Festival Workshop.

This bronze triptych, measuring 3 feet by 6 feet, was commissioned in 2003 by the daughters of the late Mary G. Hardin, founder of Piggly Wiggly grocery stores. It was to be a commemorative project for the Mary G. Hardin Art Center in Gadsden, Alabama. The plaque was designed by Sloss artist-in-residence Joe McCreary and assisted by fellow Sloss artists Matt Eaton and John Stewart Jackson.

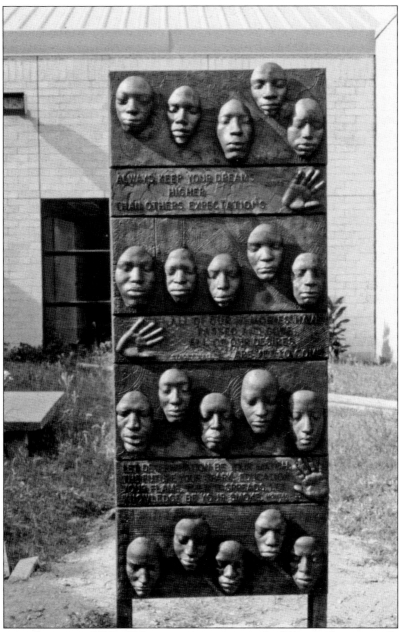

This unique sculpture is a 1988 collaborative piece overseen by Sloss resident artists Rick Batten and Vaughn Randall with students from Central High School in Camden, Alabama. The collaboration lasted two weeks. Students from the Central High English department wrote short descriptions of dreams for the future and made molds of their faces. The entire pattern was then taken to Sloss, where it was rammed in sand and poured in cast iron. In addition to working with local school groups, Sloss funds residencies for emerging artists. These residencies are intended to support the transition from academia to the professional world and provide young artists with the opportunity to create and exhibit their own works of art. In return, they receive living space, a monthly stipend, and access to the Sloss sculpture facilities. An exhibition of work created by these creative emerging artists is held each year.

In the fall of 2003, this magnificent archway was commissioned by state officials from Cheaha State Park in Delta, Alabama, to be the trailhead marker for the Pinhoti Trail. The sculpture was designed by Sloss metal artists Vaughn Randall and Julie Ward and completed with the help of Sloss's Summer Youth Apprentices.

The Pinhoti Trail sculpture is made up of several cast-iron elements bolted together and two separate bronze plaques on the stone columns. It was installed by the Sloss Metal Arts team in 2004. Since 2000, Sloss metal artists have been making unique production pieces for local and national businesses, as well as park and recreational facilities throughout the state.

This amazing 10-foot-tall sculpture was commissioned by the Five Mile Creek Partnership in Fultondale, Alabama, and purchased by a grant from the National Endowment for the Arts. The piece was created to be displayed at the future Five Mile Creek Coke Oven Park. The 1-ton steel and cast-iron sculpture was designed and built by Sloss metal artists Remy Hanemann, Joe McCreary, Julie Ward, Michael Bonadio, and Heather Spencer Holmes. "We wanted something that people could look at," stated Francesca Gross of the Five Mile Creek Partnership. "We wanted something that people could feel as well as see. We are extremely pleased with the final project." The Sloss artists spent a year preparing the project. "We toured the coke oven site, talked to people with the city and the Five Mile Creek Partnership, and worked through ideas for nine months," McCreary stated. "It was a great project to work on—it gave us the chance to be artists."

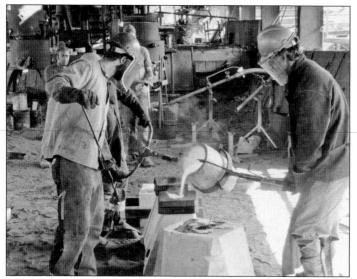

Sloss metal artists participate in a bronze pour in the Sloss Metal Arts foundry. The artists melt bronze ingots and scraps in a gas and forced-air crucible furnace at 2,000 degrees Fahrenheit. When the bronze is melted to the desired temperature, the furnace is turned off and the crucible lifted out and placed in a shank. The artists then secure the crucible and pour the metal into sand molds.

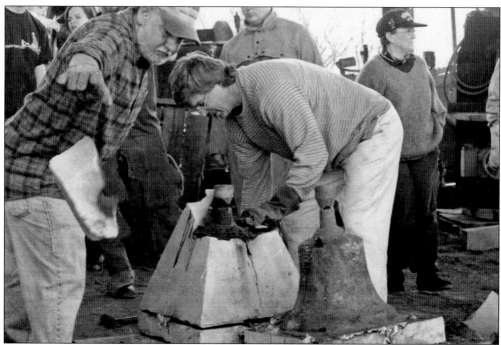

Two participants in a bronze pour workshop break open their hot molds to reveal the finished product inside. These particular molds encase two bronze bells, each weighing close to 100 pounds. Once the mold waste is removed, the bells will be degated, sandblasted, and finished to the desired surface texture.

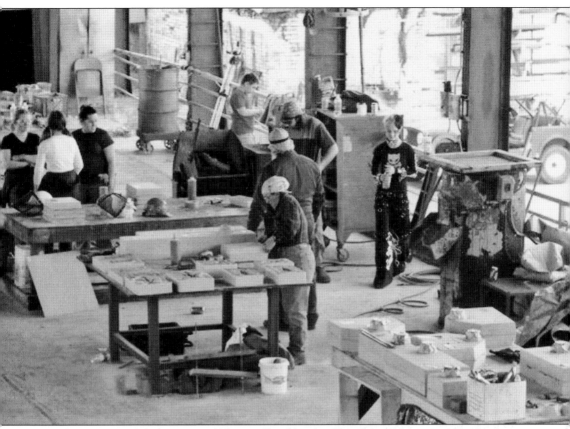

Shown here is one of the many workshops offered by the Sloss Metal Arts program. Students come from around the country to learn from the resident artists how to make patterns and sand molds and pour iron. There are also advanced workshops where professional artists come to the foundry to make molds of their work to be cast by the Sloss metal artists. The workshops consist of three days of intense work, starting on a Friday and lasting until Sunday. All aspects of creating metal sculpture are covered: mold making, casting, welding, cutting, and forging. This unique program is rooted in Birmingham's historic connection to iron and steel and replicates the industrial processes that took place in Birmingham for over 100 years. Although these industries are no longer dominant, they are still an important part of the city's economy. They are also a tremendous resource for the production of metal sculpture—the artistic expression of Birmingham's industrial heritage.

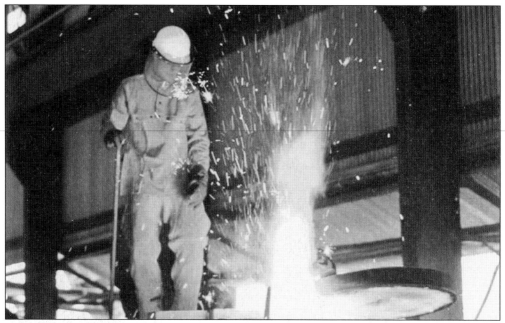

Dressed in leather safety gear, hard hat, shield, and gloves, a University of Alabama at Birmingham intern charges the furnace. Alternate charges of coke, a byproduct of coal, and iron are charged into the furnace. The coke acts as a fuel that heats the iron, causing it to melt. Once melted, the iron collects in the bottom of the furnace, where it is tapped out into a ladle when needed.

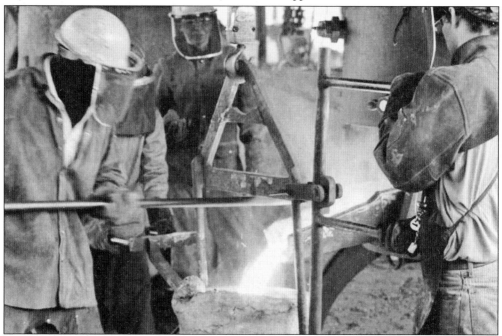

Working as a team, Sloss Metal Arts artists tap the furnace, allowing the stored iron to flow into a large ladle. The ladle, sometimes holding up to 1,000 pounds of iron, is held by a jib crane. The process of pouring the metal is done by three people. Two control the ladle while the other operates the hoist attached to the overhead crane.

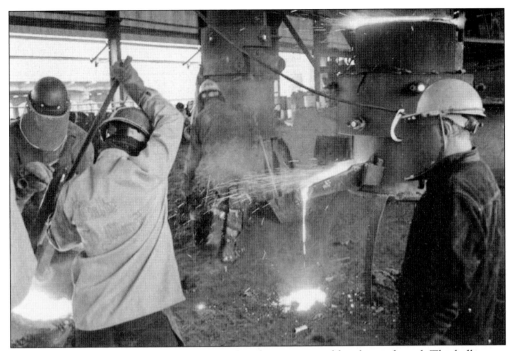

Once the ladle is full, the furnace is plugged with a mixture of fireclay and sand. The ladle crew then has to remove the slag. Slag is generated inside the furnace by impurities in the iron and ash from the coke. These impurities are lighter than the iron and float on top of the molten iron. The slag has to be removed from the ladle before the iron can be poured into molds. Sloss resident artist Julie Ward removes the slag with a long metal-handled skimmer.

At the Sloss foundry, a large sand mold is poured by three different pour crews. Sometimes it is necessary for more than one crew to simultaneously pour a mold. In this instance, the mold is long, flat, and thin. The large ladle pours the bulk of the mold, while the two ladles on the left and right pour iron in to ignite the flammable gas inside the mold. Once ignited, the gas is replaced by iron.

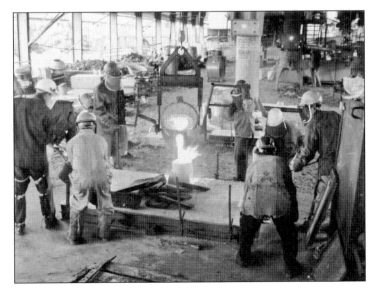

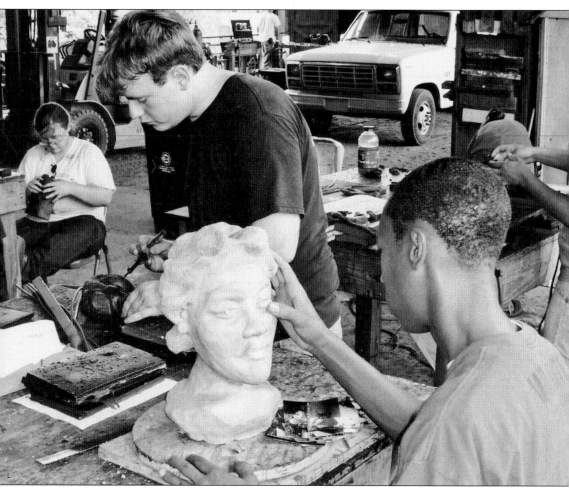

Each summer, up to 22 talented students are handpicked to work with a team of professional artists for eight weeks, at minimum wage, and learn to weld, forge, and cast iron and steel sculptures. The first six weeks are devoted to learning the various processes and making small decorative items to be sold in the Sloss Museum Store. The last two weeks are reserved for the students to make their own sculptures. Here a student is working on his final project. These types of innovative programs not only train and mold young creative minds but provide them with a sense of what life was like in a 1900s industrial blast furnace and how these facilities impacted the growth of Birmingham's Industrial District. The foundry where the students work is located on one of two 20,000-square-foot sheds where iron was cast when Sloss Furnaces was in operation.

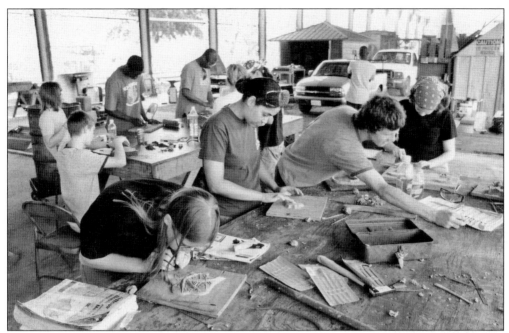

Sloss Summer Youth apprentices work from 9:00 a.m. until 3:30 p.m. Monday through Friday. Some students are able to pursue their own ideas while others need more direction. Sloss provides all the materials. The program teaches the students skills and techniques that will help them the rest of their artistic careers.

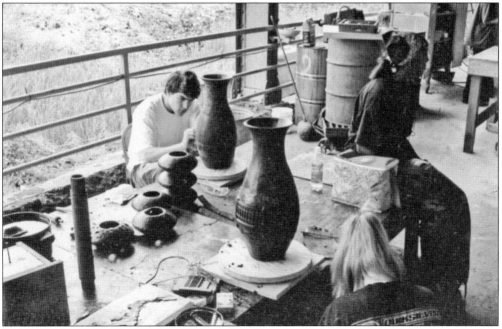

The Summer Apprenticeship Program is another example of the museum's ongoing commitment to the arts and community education. Since reopening as the only industrial museum in the nation, Sloss has served as a national and international model for large-scale industrial preservation projects. Its reputation as an active casting center is known throughout the art world.

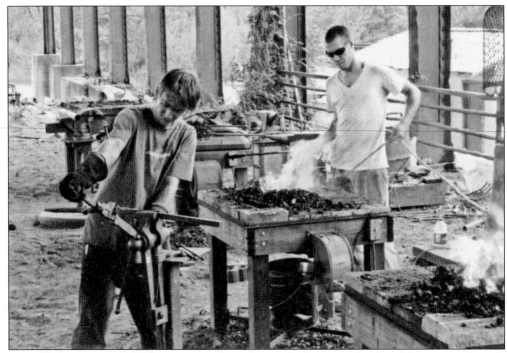

A Sloss Metal Arts resident artist and blacksmith Jarrod Christy teaches hand forging, scroll work, and other blacksmithing techniques to a Sloss Summer Youth apprentice. This apprentice is working on a twist for one of the legs for a coffee table. At the end of the program, these creative young artists present their pieces at a special exhibit organized solely for the Summer Youth participants.

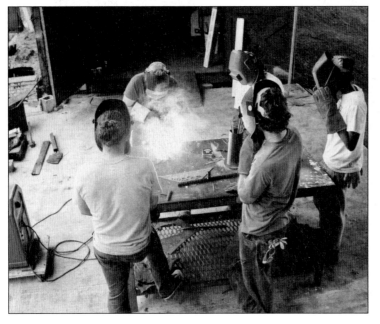

Sloss Metal Arts resident artist Heather Spencer Holmes teaches Sloss Summer Youth apprentices how to weld. The welding aspect of the program consists of torch cutting and welding and mig and stick welding. The welding instructor and the blacksmithing instructor collaborate with their projects to give the apprentices the steps needed to comfortably work with the tools essential in metal work.

This cast-iron end table with concrete top was a Summer Youth project. An apprentice laid wax and clay designs on a sand core. The core was rammed in sand, cured, and separated. The mold was then placed in a kiln, where the wax was evacuated then carved with trenches to allow the iron to reach the void made by the wax.

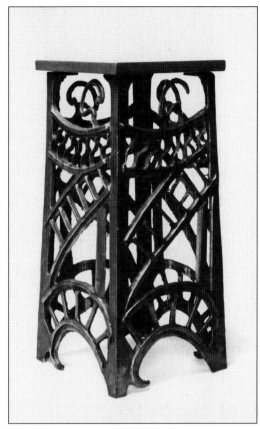

The Sloss foundry has five coke-fired furnaces for melting iron, two crucible furnaces for melting bronze and aluminum, wax and ceramic shell studios with car kiln, forklifts, a 3-ton gantry crane, and a 200-pound capacity sand mixer. The facility also has complete metal fabrication, blacksmithing, and woodworking studios. Artist studios occupy the 1926 Power House, the 1927 Pyrometer House, and a 1927 Bathhouse.

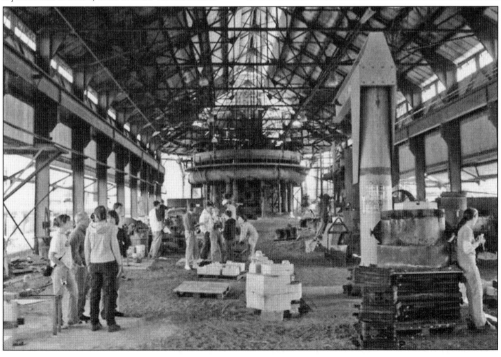

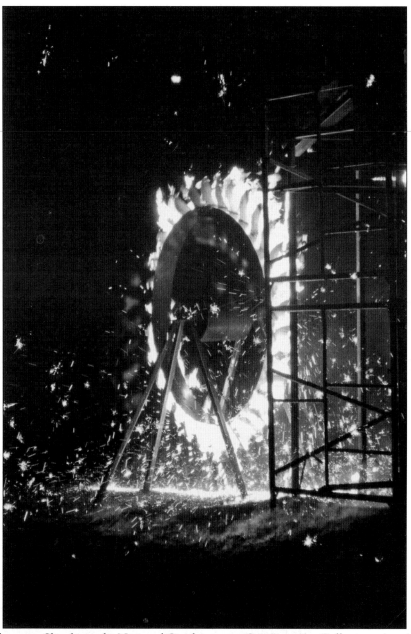

Every other year, Sloss hosts the National Conference on Cast Iron Art. Colleges, universities, and the public converge in Birmingham for art shows, lectures, workshops, panels, and performances. This biennial event grew out of the first two international conferences on cast-iron art, which were held at Sloss in 1988 and 1994. Rather than duplicate the program of the parent conference, the national conference seeks to complement it. The emphasis of the conference is on student learning and participation; the goal is the production of art. This particular image (taken during the "performances" event) is of a 20-foot paddle wheel fastened to a steel hub. A ladle full of molten iron was hoisted onto a scaffold and poured on the wheel to make it spin. As it spun, the liquid iron caught the paddles on fire and flung iron into the air.

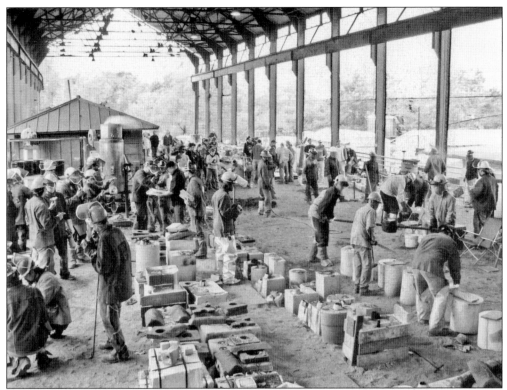

The National Conference on Cast Iron Art manages several iron pours a day. As seen in this photograph, at least four furnaces are running at the same time. These are "guest" furnaces and are running to pour workshop molds. Each furnace is run by a university team of professors and students working together.

Rochester Institute of Technology students, assisted by professors Elizabeth Kronfield and Mathew Wicker, are shown pouring workshop molds for the 2007 conference. This pour had three ladle crews, each with its own small ladle. Before the tap, the ladles were stacked under the furnace. When the furnace was tapped, the ladle crews took turns catching the iron.

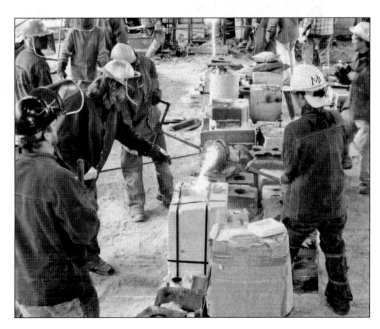

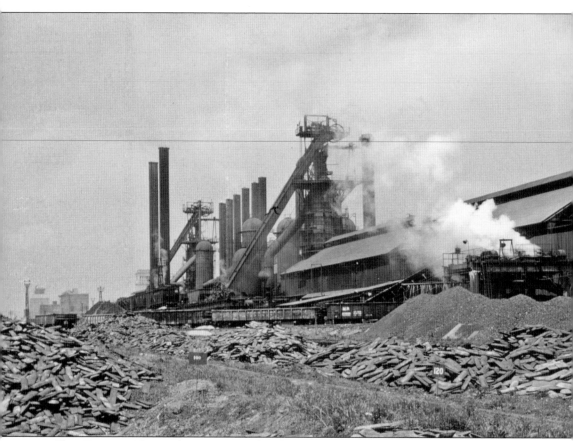

Sloss Furnaces National Historic Landmark is currently the only 20th-century blast furnace plant in the nation being preserved and interpreted as a historic industrial museum. With its never-ending maze of pipe and majestic furnaces, Sloss offers a glimpse into the great industrial past of the South and a period of time when America grew to world industrial dominance. For Birmingham, however, Sloss is important and significant because of what it represents. There is not a single major historical issue in the city's first 100 years that is not related directly to Sloss: the importance of railroads, an economy built on heavy industry, company towns, and segregation. Sloss Furnaces is more than a treasured landmark or unique industrial site; it represents the character and spirit of the South's industrial heritage. As one former worker stated, "A lot more than iron flowed from those furnaces. Our whole culture did. Our whole way of life." (Courtesy of Paige Wainwright.)

BIBLIOGRAPHY

Brackner, Joey, ed. *Spirit of Steel: Music of the Mines, Railroads, and Mills of the Birmingham District.* Birmingham, AL: Crane Hill Publishing, 1999.

Lewis, David W. *Sloss Furnaces and the Rise of the Birmingham District: An Industrial Epic.* Tuscaloosa, AL: University of Alabama Press, 1994.

White, Marjorie. *The Birmingham District: An Industrial History and Guide.* Birmingham, AL: Birmingham Publishing Company, 1981.

www.arcadiapublishing.com

MAP SEARCH

Discover books about the town where you grew up, the cities where your friends and families live, the town where your parents met, or even that retirement spot you've been dreaming about. Our Web site provides history lovers with exclusive deals, advanced notification about new titles, e-mail alerts of author events, and much more.

MADE IN THE USA

Arcadia Publishing, the leading local history publisher in the United States, is committed to making history accessible and meaningful through publishing books that celebrate and preserve the heritage of America's people and places. Consistent with our mission to preserve history on a local level, this book was printed in South Carolina on American-made paper and manufactured entirely in the United States.

This book carries the accredited Forest Stewardship Council (FSC) label and is printed on 100 percent FSC-certified paper. Products carrying the FSC label are independently certified to assure consumers that they come from forests that are managed to meet the social, economic, and ecological needs of present and future generations.

FSC
Mixed Sources
Product group from well-managed
forests and other controlled sources

Cert no. SW-COC-001530
www.fsc.org
© 1996 Forest Stewardship Council

Find Your Place in History.